Los Angeles
Cocktails

Spirits in the City of Angels

Andrea Richards
Giovanni Simeone

◆ SUNSET & VENICE ◆

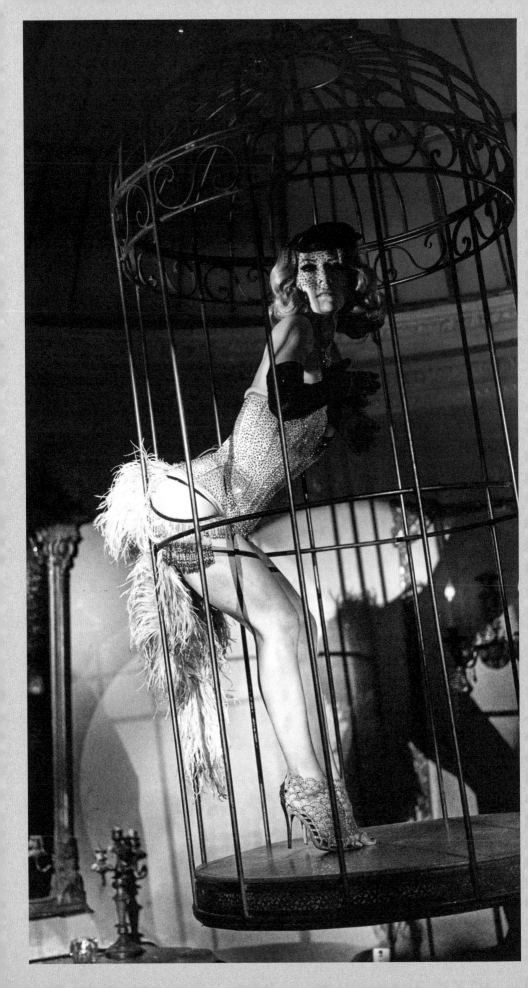

Foreword
by Vincenzo Marianella

When I began in the industry, I needed a job that would allow me to work everywhere around the world, and that's bartending. I worked in several places behind the bar, and I thought, well, it's just a job, until I went down to Australia, and I noticed they were doing great things with fresh juices. Then I moved to London, and that's where I really fell in love with the craft and the whole cocktail scene. When I came to Los Angeles, I was offered the possibility to work at Providence, and that's when everything started for me.

I began working at Providence in 2005, when it opened. Before that, I'd been in Los Angeles for a year and a half and couldn't find a single bar that would allow me to use fresh lemon and lime juice. I probably applied for thirty bartending jobs, and no one would let me use fresh ingredients—it just wasn't done. That was the scene at the time. So while I'd experienced a cocktail scene in London during the '90s, it wasn't really in LA yet.

Finally, at Providence, Donato Poto (co-owner, general manager) and Michael Cimarusti (co-owner, chef) pushed me to be creative. Both were mentors for me. Donato taught me so much about hospitality and how to act behind the bar. Michael taught me about flavors and helped develop my palate. And I had the freedom to do whatever I wanted—except, of course, they had to approve the menu.

There's always an evolution to food and drink, and there are certainly trends. But once the trend is over, usually the good stuff stays. It's a good moment for cocktails right now because there is the understanding of the quality ingredients—that's what matters. Then if you shake in a certain way, if you stir in a certain way, that doesn't really matter that much. When I was at Providence, the craft cocktail scene in LA went from zero bars to many. Today, we're still a drop in the ocean, but things have evolved. More people are investing in quality products—guests want to spend their money for quality, not quantity.

This is an exciting moment to be in the United States if you work in the culinary world or in cocktails because Americans are developing their palates. It's not steak and potatoes anymore. Even in small towns now you can find restaurants that use farm-to-table products. That was almost impossible to find before.

I think LA is the most underestimated cocktail scene in the country, especially compared to other big cities. A little bit of this is the bartenders' fault—there's the perception in LA that people only care about being actors and musicians, we don't care about anything else, which is not true. Finally, it's starting to be recognized that bartending is a career choice; it's not just something actors do.

When I started here, Los Angeles was still a big vodka city, and then it moved to bourbon; now it's moving to agave spirits. The next trend is amari. The scene is always evolving. Part of that is the change in palates; the other is the change in generations. The new generation doesn't want to drink what their parents drank—if their parents drank vodka, they drink tequila. The early '90s were all about vodka—today, a lot of people make fun of that, but we wouldn't be here today if it wasn't for the apple martini or the cosmopolitan. And if those cocktails are made properly, they're still good cocktails.

To me, the classic cocktails must include only the original ingredients. The bartender's work is to adjust the proportions according to what ingredients you're using—that's the art. The better the bartender, the better the drink. But I think the classic cocktail revival is fading away a little bit; there's a move back to originality now. Part of that is, again, generational—you have new bartenders coming up who are tired of making classic cocktails. They want to do something different. But the good thing is they aren't cocky. There was a period of time when every bartender was a "mixologist," and so many wanted to be famous. That moment is over. Instead, you have an understanding of techniques, a respect for the classics, and a desire to play— to modernize the classics with new flavors or technique.

What's important to me about a bartender is the personality of the bartender and not what he or she is doing behind the bar. The cocktail is the garnish of the experience; it's not the experience itself. People come to bars to have fun first. Cocktails are very, very simple. The point is to find a bar that makes you feel at home; the hospitality—not the drink—is the most important part.

Of course, nowadays, bars are like restaurants—to be successful they have to have quality. Otherwise, they are going to shut down in a week, because people have a respect for quality, a taste for it. I like a bartender with some originality; but mostly I like one who makes people feel welcome.

There's no one way to make a great cocktail bar; there's no one style. There are many kinds of bars—which one is the best depends on what you are looking for—whatever you're in the mood for. When I go out, I want to go somewhere friendly and busy. My favorite bar in Los Angeles—that I used to go to all the time—is a dive bar.

Don't get me wrong, I like a good cocktail—but to me, no drink is mind-blowing. The drink alone is not the experience; I'm at a bar to socialize, to have an experience. When people value the drink over the experience, to me they are missing the point. But that's their problem—everyone is free to think the way they want.

The Spirit of Los Angeles in Spirits

I have seen purer liquors, better segars, finer tobacco, truer guns and pistols, larger dirks and bowie knives, and prettier courtezans here, than in any other place I have ever visted; and it is my unbiased opinion that California can and does furnish the best bad things that are obtainable in America.
—Hinton Helper, as quoted in David Wondrich's *Imbibe!: From Absinthe Cocktail to Whiskey Smash, a Salute in Stories and Drinks to "Professor" Jerry Thomas, Pioneer of the American Bar*

Oh, how I love the above quote, and when I came upon it early in David Wondrich's fantastic and authoritative history, I laughed and poured myself another drink. "The best bad things" might be the tagline boosters of Los Angeles have always looked for! Hasn't our sunny city—named to honor angels—always been more renowned for its grisly crimes, deranged sex cults, disillusionment, and the possibility of total apocalypse (earthquakes, mudslides, fires)?

Los Angeles is the birthplace of film noir, hard-boiled detective fiction, fast-talking broads, freeways, and fast food. Outsiders make fun of the city's disposability, decrying that the buildings are made of cardboard, and heckle our sense of history and aesthetics. For most of the twentieth century, Los Angeles was ridiculed and scorned. But go ahead, sneer all you want, suckers, because as home of the Manson murders, Hollywood, and the San Fernando Valley, we can boast the *best* bad things around. With so much

vice in the air, circling its citizens along with the smog and the scent of orange blossoms, LA is bound to be a city with good bars, right?

It is tempting to do nothing more than quote Raymond Chandler endlessly on the subject. Has any other writer so consistently captured the gritty glory of drinking in Los Angeles? I dare you to refuse a tipple after reading how Philip Marlowe, Chandler's most famous character, uses a single sip in *The High Window* to loosen up a tight-lipped police lieutenant:

"Then he picked the glass up and tasted it and sighed again and shook his head sideways with a half smile; the way a man does when you give him a drink and he needs it very badly and it is just right and the first swallow is like a peek into a cleaner, sunnier, brighter world."

Chandler's work is full of tough guys—and even tougher women—holding their liquor under the most extreme circumstances. In this hard-boiled world, Angelenos need a drink because alcohol is a respite from those devil winds outside; what's in the glass—be it a coupe, a rocks, or a highball—offers entrance into a sunnier, brighter world. To Chandler's characters drinking is integral, and the clubs and bars where these degenerates gather are the heart of the city, the clinking of ice against glass its pulse.

What does all this say about our real city? As is often the case, the imaginary plays out in real time; Chandler, along with so many other dystopian artists, left his mark on Los Angeles. It's hard to enter a bar like **Boardner's** (page 94) or the **Frolic Room** (page 168) and not feel Philip Marlowe's smoky breath on your neck.

I've had the good fortune to call Los Angeles home for two decades now, and for all its legendary depravity and many instances of real corruption, it's also a pretty nice place for more ordinary pursuits: beach trips, walks in the park, raising a family. The city is sunshine and noir; it's a little bit of both and a lot of in-between. Los Angeles is an eclectic place with a dynamic history of interactions (some civil, some not) between people. The result is a multiethnic city that is in constant flux, with one thing that goes unchanged being its incredible diversity.

And that's what makes LA a great place to drink: diversity. The cocktail scene isn't one scene; it's many. Depending on the neighborhood, you can find anything from a hole-in-the-wall that opens at 6 a.m. to a high-end hang dedicated exclusively to a single spirit. Los Angeles has plenty of historic watering holes, fantastic dive bars, bars masquerading as dive bars, cocktail lounges, clubs of all stripes, neo-speakeasies, and places that were actual speakeasies.

One thing *Los Angeles Cocktails* tries to avoid is the inclusion of too many restaurants, which is difficult since

great cocktail programs have become de rigueur. There is something sanctified in the practice of merely going out for drinks. In this hybrid world where everything is available all the time and multitasking the norm, it is refreshing to sit with a single purpose and a single drink. A cocktail has the wonderful ability to slow the passage of time; sipping an old-fashioned has replaced a smoke break.

When we first started mapping *Los Angeles Cocktails*, the idea was that bars in LA might be more dramatic, more immersive than they are in other cities. That similar to Hollywood films, they create narratives for patrons to fall into, departures from the real world into a better one. But that notion soon faded because the more bars we visited, the more we realized that even at the most exotic of locales what mattered most was feeling a connection to the place or the people around. The drinks and decor could be a portal, but no matter what the bar—a honky-tonk or a retro fantasy—the one thing that mattered even more than the cocktail was to feel welcome. Bars are, at the end of it all, about interaction and connection, whether you're there to sip solo or trying to pick someone up. Even a bad drink can be OK in a good place.

But we'd rather not have bad cocktails, which is why the criteria for the places contained within these pages includes an assurance you won't be served swill unless that's what you ask for. But the most important criteria is not the cocktail alone: it is the sense of

place. Good bars feel connected to the neighborhoods and the people they serve.

The selection of bars and cocktails in this book came about in an admittedly haphazard way—is there any other way when your subject is booze? Some of my personal favorites didn't make a mention in what follows. Apologies to the Sunset Strip's Rainbow Bar and Grill; Everson Royce Bar in the Arts District; downtown's El Dorado; the Short Stop in Echo Park; The Prince in Koreatown; and the iconic HMS Bounty, just to name a few. While such absences are regrettable, they are also inevitable.

This is not an all-encompassing guide to bars in LA, nor is it an ode to craft cocktails. It is simply a series of recommendations, offered in much the same way that I would offer you a drink in my home—I like this, maybe you will too.

Many of the selections herein have history to them; bars and clubs are preservation halls for a myriad of cultural histories, and one of the best parts of the resurgence of downtown is that so many great, old spaces are getting dusted off and reused. Some of these aspire to be neighborhood bars; others are lounge-style neo-speakeasies or elaborate, evocative clubs with dress codes and table minimums. There's a place out there for everyone and for all types of fun, from the bingo parlor to the brothel. As Whitman might have said (but

certainly didn't): Los Angeles is large; it contains multitudes. That is certainly true when it comes to bars.

Just as we think of the city in simplified terms, so too we often approach our spirits—we all think we know what we like to drink. There are whiskey people, gin people, beer people. I knew for sure I had no use for vodka until a **Campanula Sour** (page 87) at the **Copa d'Oro** (page 78) made me revisit my prejudices. Isn't that the way it should be: neither our cities nor our selves should be confined to habit? We should always explore. Every night out is an adventure.

While researching this book—and what rigors that required—I was witness to many wonderful activities and interactions in bars and, sadly, for the sake of anecdotes, few illicit ones. At **Harvard & Stone** (page 228), I ran into an old acquaintance I hadn't seen in awhile as she prepped to take the stage, her music career firmly launched. Outside of a downtown bar, I happened to cross the street at a tragic moment and witnessed a suicide jump from the top floor of a nearby hotel.

Los Angeles is a city of dreams and disappointment, life and death, but mostly it is, like other places, a city of souls—from near and far—seeking to connect with each other. If we can connect our spirits over spirits, I say serve it up. Cheers to this glorious— and gloriously complicated—city! Los Angeles makes a fine muse and an even finer martini.

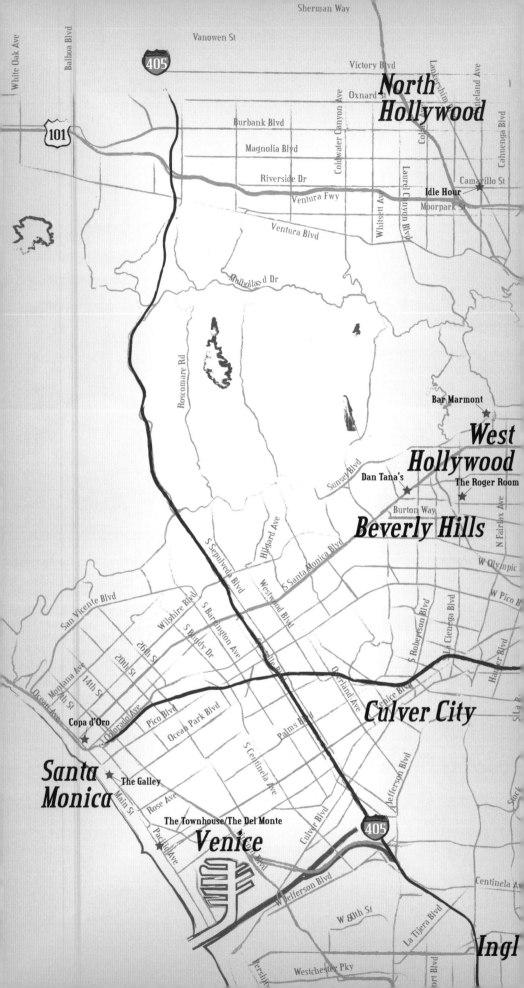

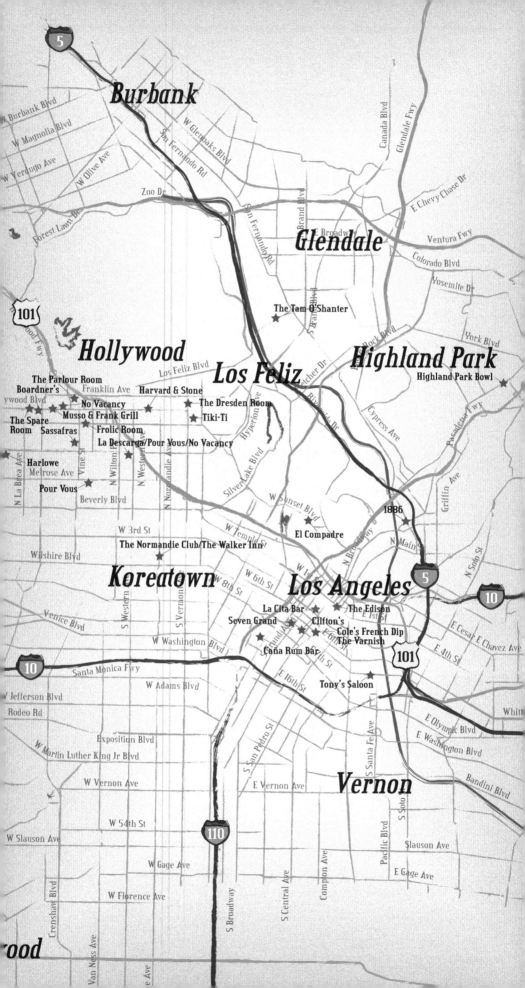

Step Inside for a Drink...

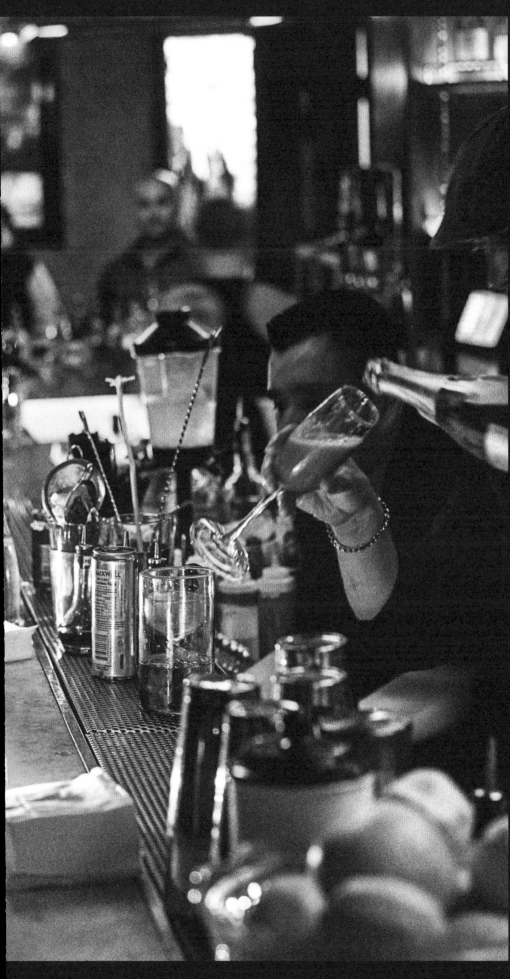

Whiskey/
Whisky

"There is no bad whiskey. There are only some whiskeys that aren't as good as others."

Raymond Chandler

Manhattan

Ingredients
- 2 oz. rye whiskey
- 1 oz. sweet vermouth
- 2 dashes Angostura bitters

Directions
1 Stir ingredients over ice.
2 Strain into a chilled cocktail glass, and serve.

Recipe courtesy of
Seven Grand
(page 28)

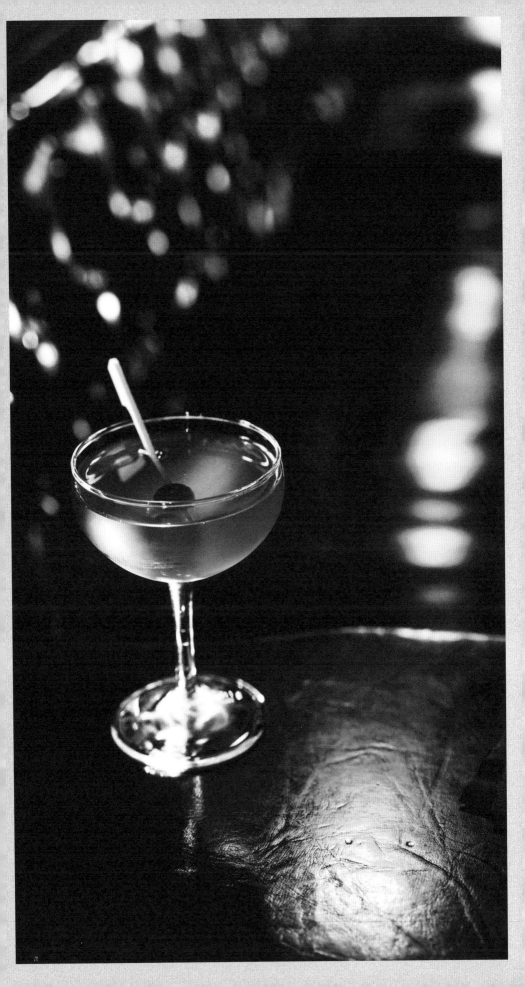

Seven Grand and Bar Jackalope

"Well, show me the way / To the next whiskey bar / Oh, don't ask why / Oh, don't ask why," sings Jim Morrison in the Doors cover of Bertolt Brecht's "Alabama Song," and if you ask for a whiskey bar in Los Angeles, **Seven Grand** is what you are going to get. Not because there aren't others—there are many, and many of them good—but because this was the place that inspired most others. When it opened in 2007, like many of **213 Hospitality's** (page 158) other downtown ventures, Seven Grand set a new standard for sophisticated sips in an unpretentious and fun setting.

As you walk up the stairs to the second floor of the historic Brock and Company Building (which once housed Clifton's Silver Spoon cafeteria), the plaid carpeting serves to set the scene, which takes you out of downtown's old jewelry district and into the hunting lodge of your man-cave dreams. Taxidermy and animal horns abound, the unfortunate creatures adorning the walls and lamps. The light is low, the wooden bar is warm, and the whiskey is plentiful—there are more than four hundred makes behind the bar. This is one of the largest collections of premium whiskey available in the West, and bottles are displayed in vintage cases from the building's original owner, a jewelry company. Alongside the bottles you'll find a wonderful collection of vintage barware and whiskey artifacts, including rare bar books and menus, the result of a collaboration between Silver Lake retailer Bar Keeper and

Seven Grand and Bar Jackalope
515 W. 7th St., #200
Downtown
sevengrandbars.com

the Museum of the American Cocktail (MOTAC); the exhibit is officially called the MOTAC Whisk(e)y Gallery.

If you haven't already noticed from a bar with a gallery inside, there is an educational component to Seven Grand, which also offers popular tastings through its Whiskey Society, highlighting master distillers. But you can also just come and enjoy an exquisitely handcrafted cocktail while listening to live jazz or shooting pool. Whether you're a whiskey aficionado or just a player, there's room for you in the fox-and-hound, clubby atmosphere.

Like other 213 Hospitality bars, Seven Grand has a hidden back bar—the intimate, twelve-seat **Bar Jackalope** that has its own entrance (it's done speakeasy-style, with instructions in English and Japanese next to a light switch). As the instructions imply, the small whiskey lounges the barkeeps visited in Japan are the inspiration behind the bar. Though the menu boasts more than 120 selections of Japanese whiskey, plus American bourbons and ryes, there are only three cocktails available: an old-fashioned, a **Manhattan** (page 26), and a highball. Guests can even buy their own bottles and store them in a rented locker. The idea is ease, simplicity, and enjoyment. What does it mean when the most serious whiskey bar in town is named after a mythical, horned hare? It means you're in a city with a good sense of humor that doesn't take even the most serious of spirits too seriously.

Rye of the Beholder

Ingredients
- 1.5 oz. Rittenhouse 100 proof rye whiskey
- 0.75 oz. Amaro Nonino
- Orange twist

Directions
1 Build in an old-fashioned glass.
2 Add Penny Pound block ice.
3 Stir and serve.

Recipe courtesy of
Tony's Saloon
(page 158)

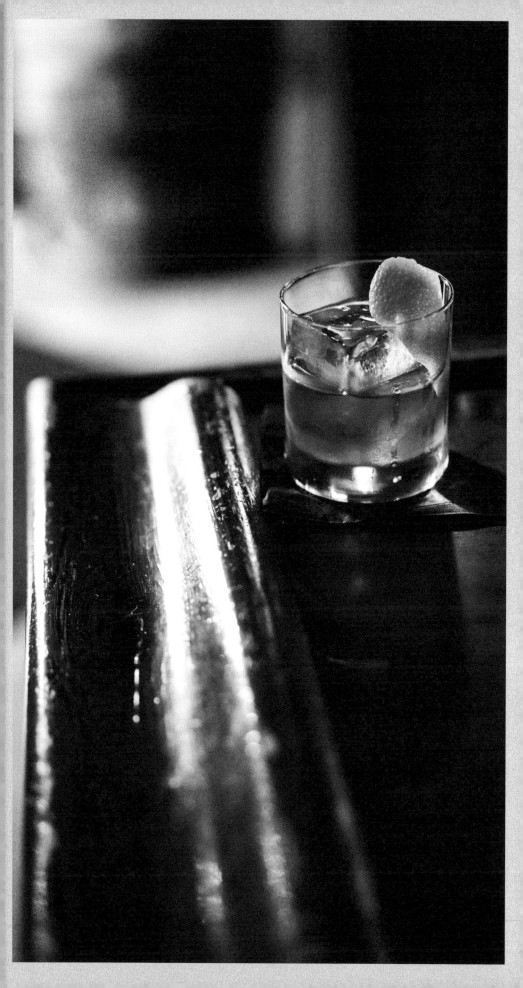

The Edison

Located in the basement of the 1910 Higgins Building, the cavernous **Edison** is a striking amalgamation of the past and the future, a steampunk vision of Los Angeles's history that includes both *Blade Runner* and burlesque. If it sounds like a lot, that's because it is: a massive bar/lounge in a one-hundred-year-old building that incorporates design elements of Victorian, Art Deco, Art Nouveau, and Gothic styles—all in an underground space that was once LA's first private power plant. When designer and proprietor Andrew Meieran—the same fellow who rehabilitated **Clifton's** (page 182)—initially toured the building, he had to do so by raft; it was so rundown and neglected that the lower floors were under water. But the industrial relics from the early twentieth century that he found inspired him and became the basis of the bar: the cleaned-up steam broiler, rows of generators, and a colossal brick furnace remain and set the tone for the rest of the club's aesthetic.

Taking the two sets of stairs down from the alleyway entry feels like a descent into an underworld—the lighting is low but warm; there are silent films projected on a wall. Meieran has called the Edison "an industrial cathedral," which sums up the interplay of the mechanical and sensual—the latter of which is often highlighted in the cabaret-style shows that feature aerialists, burlesque dancers, and jazz or blues musicians.

The Edison
108 W. 2nd St. #101
Downtown
edisondowntown.com

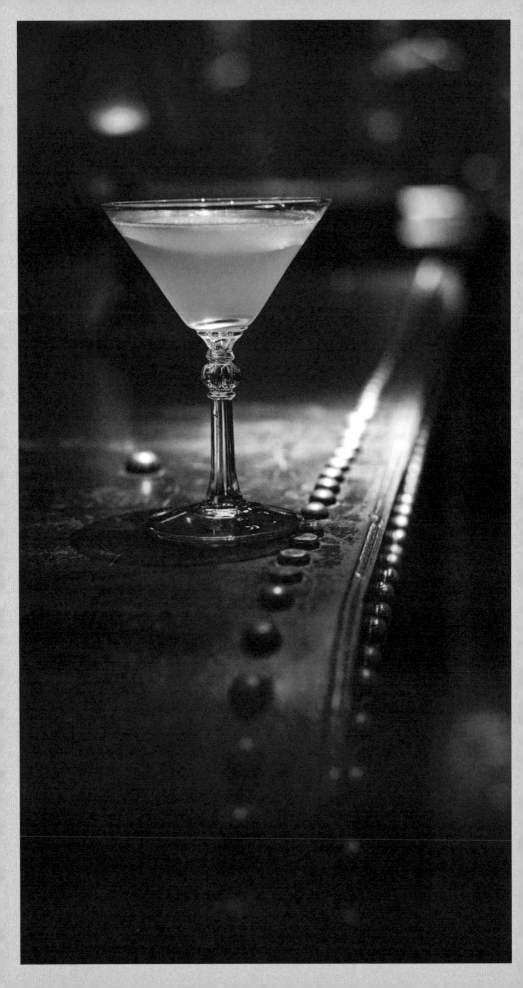

The Edison

Ingredients

- 1.5 oz. Woodford Reserve bourbon *(The Edison has its own blend and barrel)*
- 0.75 oz. lemon juice
- 0.5 oz. Belle de Brillet
- 0.5 oz. honey
- Orange zest for garnish

Directions

1 Shake, and fine strain into a martini glass.
2 Finish with an orange zest.

Recipe courtesy of
The Edison
(page 36)

Townhouse and The Del Monte

On Windward Avenue, just past the glowing sign spelling out "Venice" and a mere block from the Pacific, you will find one of the oldest bars in Los Angeles, and definitely the oldest bar in Venice. Established in 1915 by Cesar Menotti, Menotti's Buffet was a gathering spot for the community from day one; here, more than a century ago, a tipple could be had with your neighbor (the original name of the establishment is still visible in the tile floor at the bar's entrance). But when Prohibition arrived, the proprietor had to get creative; he transformed his spot into a grocery, moving all the bar equipment down into the basement. The subterranean space became a speakeasy for those in the know, accessible only through a trapdoor and a rope-operated dumbwaiter. The clandestine setup also allowed Menotti to continue supplying the nearby hotels with illegal liquor, since his basement attached to a maze-like structure of mostly forgotten maintenance tunnels beneath Venice—a relic from the area's founding as Venice-by-the-Sea, a city of canals. The goods came by boat from Canada and then were transported by smaller boats to the tunnels via an entrance located somewhere beneath the Venice pier.

When Venice was annexed by the city of Los Angeles in 1925, the city's namesake canals were all filled in and the old tunnels sealed up and forgotten—except by bootleggers, for whom they served as vital pathways for getting hooch into the city.

Townhouse and The Del Monte
52 Windward Ave.
Venice
townhousevenice.com

Today, a boarded-over doorway
is visible in the back room of the
Del Monte; this is one of the few
remaining entrances to the tunnels
to still exist, and it's been sealed for
decades. Nowadays, the upstairs space
is back to unabashedly being a bar,
the **Townhouse**, which is known
for serving its craft cocktails in an
unpretentious space. Downstairs,
the Del Monte has been restored (a
stairwell was added linking the two
in the 1960s so that patrons no longer
needed the dumbwaiter). In the current
era of the neo-speakeasy, it's like a
breath of fresh air to see the real thing;
although that air also has a slightly
musty scent to it: the result of at least
one hundred years of salty old tales,
some of which are still left to discover.

Boulevardier

Ingredients
- 1.5 oz. Buffalo Trace bourbon
- 1 oz. Carpano Antica Formula sweet vermouth
- 1 oz. Campari
- Orange peel for garnish

Directions
1 Combine ingredients in shaker with ice.
2 Stir well, and strain into chilled cocktail glass, or old-fashioned glass with ice.
3 Garnish with orange peel.

Recipe courtesy of
Townhouse
(page 40)

The Spare Room

The oldest hotel in LA, the 1927 Roosevelt (named for the twenty-sixth president) was originally financed by early film luminaries, including MGM head Louis B. Mayer, silent film stars Mary Pickford and Douglas Fairbanks, and theatre impresario Sid Grauman. The hotel has been a popular haunt with the film crowd ever since: it was the site for the first Academy Awards ceremony, and many film stars took up residence here (Marilyn Monroe lived for two years in the poolside cabanas). Although the epitome of swank during the Golden Era, the hotel went into serious decline during the 1950s. Thankfully, the landmark was restored to its former glory by a series of renovations, including the David Hockney mural at the bottom of the swimming pool.

During the latest redo, a storage space on the hotel's mezzanine level was transformed into the **Spare Room**, a "gaming parlor" that seeks to summon up a tony basement bar of the type that might be found in a Rockefeller residence. Two beautiful vintage bowling lanes were brought in; they are wood and go beautifully with the Art Deco-style lighting, brass bar, and expansive view of the boulevard below. The decor is Prohibition-era style, and the cocktails reflect a fondness for the era; the bar even offers communal punch bowls for patrons as they play dominoes or delight in some other light sport, be it bowling or flirting. Both Aidan Demarest (**Seven Grand**, page 28) and Yael Vengroff (**Harvard & Stone**, page 228) helped develop the bar's signature cocktails.

The Spare Room
7000 Hollywood Blvd.
Hollywood
spareroomhollywood.com

Bridge and Gin GAMBITRY

the ART of WINNING all of the time

by Clem Stein Jr.

with SPECIAL GAMBITRY by CHUCK LAKEFIELD

foreword by CHARLES H. GOREN

illustrated by AL ROSS

Lucky Smoke

Ingredients

- 1.5 oz. Nikka Coffey Grain Whisky
- 0.5 oz. Smith & Cross Navy Strength rum
- 0.25 oz. banana liqueur
- 0.25 oz. vanilla syrup
- 2 dashes Miracle Mile coconut pandan bitters
- Pandan leaf for garnish

Directions

1 Combine ingredients in a rocks glass filled with ice. Stir with a bar spoon.
2 Wrap the pandan leaf around the inside of the glass, and serve.

Recipe courtesy of
The Spare Room
(page 46)

The Parlour Room

Part of Craig Trager's Vintage Bar Group, when the **Parlour Room** opened in 2010, it was a tonic to the VIP-laden, velvet-rope-and-bottle-service-only trend that was dominating the Hollywood scene. Instead, Trager wanted to create a neighborhood bar that didn't look like a dive but had the heart of one: a place where regular folks could go and the bartender would not only know the patron's name, they'd know his or her drink as well. Maybe that doesn't sound revolutionary, but it was. The Parlour Room isn't a *lounge*, or a *club*; it's a bar. And maybe Trager, a native Angeleno who has launched six other successful bars, turned his back on flash because, well, *mi casa es tu casa*; and he wants people to be comfortable in his bar.

Just as the vibe is low-key, so is the entry. The only sign outside is a neon one that says "cocktail" above the door. Before Trager took over the space, there were several incarnations as other bars here, the best of which was Goldfinger's, a grubby club bedazzled in gold lamé and designed to look like Pussy Galore's bedroom. The lamé is long gone; instead, inside is dark wood, flocked wallpaper, and a twenty-foot marble bar with crystal chandeliers above. While they'll make anything and sell plenty of beer, the specialty cocktail menu is your best bet. Mixes are in vintage bottles, and drinks can be enjoyed on the back patio with a true anachronism: a cigarette.

The Parlour Room
6423 Yucca St.
Hollywood
vintagebargroup.com/the-parlour-room.php

Black Cherry Manhattan

Ingredients
- 6 muddled Luxardo cherries
- 2 oz. Woodford Reserve bourbon
- 1 Luxardo cherry for garnish

Directions
1 Combine cherries and bourbon.
2 Pour over ice in bucket glass.
3 Garnish with one Luxardo cherry on a pick.

Recipe courtesy of
The Parlour Room
(page 52)

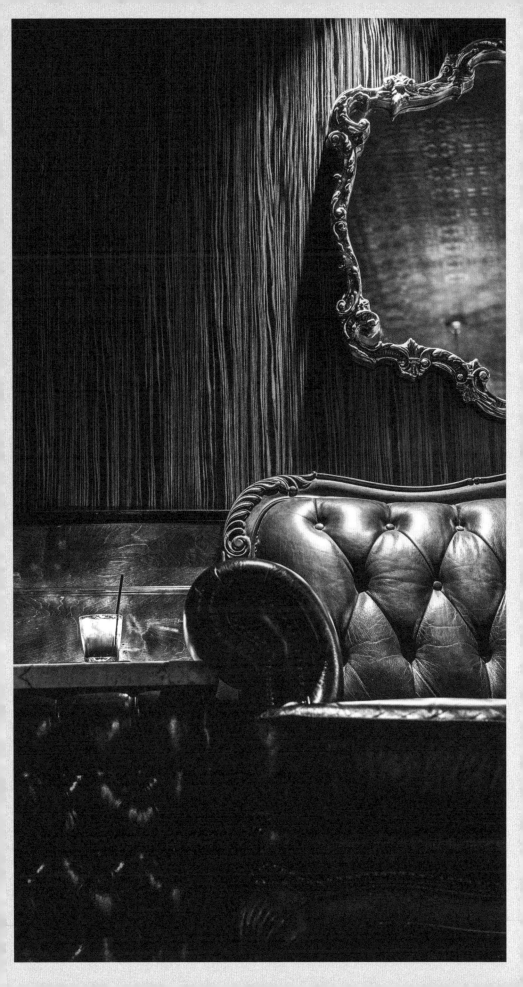

Whiskey Sour

Ingredients
- 2 oz. whiskey
- 0.75 oz. simple syrup
- 0.75 oz. lemon juice
- Egg white from one egg

Directions
1 Combine ingredients in cocktail shaker, and shake well.
2 Add ice to shaker, and shake until chilled.
3 Double-strain into chilled cocktail glass, or into an old-fashioned glass over ice.

Recipe courtesy of
Cole's French Dip
(page 58)

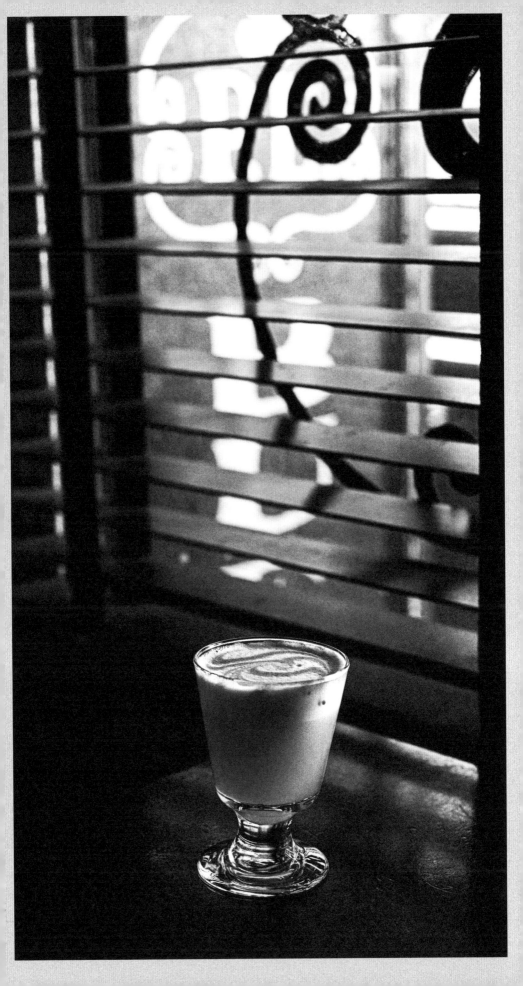

Cole's French Dip and The Varnish

For more than a century, there has existed a bitter rivalry in Los Angeles regarding who created the french dip sandwich: **Cole's**, opened in 1908, is one of the two contenders. The other is Philippe's, located just on the edge of Chinatown, but since we're not talking sandwiches, who's to say? Instead, let's revel in the fact that our fair city offers not one but two one-hundred-year-old establishments that fight over the proper placement of *au jus*. To anyone who accuses Los Angeles of not having history: check out our beef over *beef* and rethink things.

But on to Cole's, because you are going to want to stay here a long while and soak up the atmosphere like a bun soaking up *au jus*. The oldest public house and saloon in Los Angeles (closed only for renovations in 2008) opened as Cole's P.E. Buffet in 1908 and served as a pit stop for the thousands of riders of the city's massive interurban electric rail system, the Pacific Electric Railway (hence, the P.E. before Buffet). Known colloquially as the Red Car system, the beautiful Beaux Arts building that houses Cole's in its basement was once the terminal for the lines south and east of downtown. Today called the Pacific Electric Building, when it was constructed in 1904 the building was the largest in Los Angeles. Along with the lower floor terminal, P.E. housed its offices here; and the fancy Jonathan Club, a private club for the city's well-connected businessmen, occupied the building's top floors.

Cole's French Dip and The Varnish
118 E 6th St.
Downtown
colesfrenchdip.com
thevarnishbar.com

Today the spirit of the red car lives on in the bar, as do the decor preferences of saloon founder Henry Cole, who did much of the decorating in 1908 DYI-style. Cole fashioned tables out of the sides of the old, wooden red cars and threw sawdust on the floor. While neither of these remains, the bar does still boast original glass lighting, Tiffany shades, flocked wallpaper, penny-tile floors, and its massive mahogany bar. During Prohibition, the saloon survived by serving bitters and near-beer; on repeal day in 1933, Cole's sold fifty-eight thirty-two-gallon kegs of the real stuff.

After ninety-nine years, the steady deterioration of business downtown led Cole's to close, but only long enough for Cedd Moses's **213 Hospitality** (page 158) to swoop in and save the place. After a major remodel and restoration, the historic cultural monument reopened in its current incarnation in 2008 to much acclaim, including a Preservation Award from the Los Angeles Conservancy. The drinks, like the bar itself, harken back to these historic days, with an emphasis on classic cocktails—the 1926 Cosmopolitan, which resembles the sugary staple of *Sex and the City* in name only, and pre-Prohibition offerings like the Corpse Reviver No. 1 are carefully made. But there's also room at the wooden bar for so-called *new* classics, like the popular Penicillin, which was created in 2005 but feels right at home here.
In 2009, proprietor Cedd Moses partnered with the two of the city's

most-lauded bartenders, then-213 bar director Eric Alperin and Sasha Petraske, founder of New York's famed Milk & Honey. Their idea was to transform a storage room at the back of Cole's into a speakeasy-style bar that would focus on meticulously made cocktails. (Allegedly, this storage room was where Cole's regular, Mickey Cohen, conducted the business of roughing people up.) For Alperin, the endeavor was all about historical precision and specificity—a tiny bar that would offer a select few classic and classically inspired *original* cocktails served with the best quality ingredients and care. From the moment it opened, the **Varnish** changed the city's cocktail game; the menu was concise, with intense focus on historical precision. Focusing on drinks from the turn of the century to the 1950s (and some 1960s), the Varnish sought to recreate the drinks as accurately as possible, with the serving glass, ingredients, and even hand-carved ice. (The laborious process by which they make their pristine ice spurred its own entity: Penny Pound Ice.) Even if there were crowds (and when they first opened there were *always* crowds), bartenders took the time to craft a perfectly rendered cocktail from behind a bar that looks like a cross between a scientist's lab and an alchemist shop, with ample fresh produce, bar tools fastidiously arranged, and a range of colored liquids—infusions, juices, mixers—in rounded-edge beaker bottles. In 2012, the Varnish won the title *Best American Cocktail Bar* at the Tales of the Cocktail Spirited Awards in

WE DO NOT EXTEND CREDIT TO STOCKBROKERS

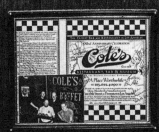

New Orleans, which only cemented what folks in Los Angeles already knew: you might get the best drink of your life here.

Today, the Varnish isn't any different. It's still hidden at the back of Cole's—though everyone knows it's there—and its proprietors and bartenders remain committed to serving classic cocktails. They are purists but not to a fault. The goal is to serve a cocktail worthy of the drink's rich heritage, taking care not to add any unnecessary steps that would distract from the experience. It's especially pleasant to go to the Varnish just as it opens, when you can easily snag one of the wooden booths designed to resemble old trolley line seats and savor your drink long enough for the live jazz to start (there's an upright piano in the center of the room). The slow and steady melting of the giant block of ice in your drink, which is designed with its dissolution in mind, is a nice way to gauge the passage of time.

As to the question of whether you should do your drinking at Cole's or the Varnish, by golly, life is short: do both. The only decision to make is which comes first: the red car bar of Cole's or the Varnish's windowless room? That all depends on when and where you want to eat the french dip, which will, inevitably, accompany one of the cocktails. These two venues share nicely; their coexistence proves you can't have too much of a good thing or too many good cocktails in one square block. One is a historic saloon; the other is devoted to preserving the heart of historic saloons: its drinks. One begat the other, and the existence of both creates ongoing hope for the survival of our species: maybe we won't always take the past for granted. Maybe we will think more about the steady march of progress and what gets lost along the way.

With Cole's French Dip, 213 Hospitality preserves a vital piece of Los Angeles cultural history, allowing new generations to populate the same public hall their great-grandparents might have; they can even sit at the same bar and order the same drink. Oh, how we wish the same fate had befallen other iconic watering holes in Los Angeles, like the recently shuttered Formosa Café. Or Al's Bar downtown. Or Yee Mee Loo in Chinatown. Suffice it to say, many wonderful watering holes have been unceremoniously lost as neighborhoods or even temperaments change. While one can deeply appreciate Cole's and the Varnish for what they do to quench the thirst, it's perhaps even more admirable what they do for the Angeleno's soul: they remind us of the treasures still here and that trends have got nothing on *time*.

Old-Fashioned

Ingredients

- 2 Dashes Angostura bitters
- 1/2 teaspoon-sized white sugar cube (198 cubes per pound)
- Dash of club soda
- 2 oz. spirit of your choice
- Large block of ice, straight out of the freezer
- Long orange peel for garnish

Directions

1 Add the bitters to the bottom of a 9 oz. rocks glass.

2 Add sugar cube.

3 Add a dash of club soda and muddle contents until a paste is formed, but not so much that the sugar is completely dissolved.

4 Add your spirit.

5 Make sure your block of ice is frosty and cold from the freezer, not sweaty from sitting out.

6 Use the spoon to scrape the bottom of the glass under the block of ice once or twice; this dislodges the muddled sugar from the bottom of the glass.

7 Stir the ice.

8 Squeeze the orange peel so that the essential oils rain down on the cocktail. Lightly brush the peel around the rim of the glass, and place the peel in the drink so that it looks nice and can be easily removed by the guest if desired. Serve immediately.

Recipe courtesy of
The Varnish
(page 58)

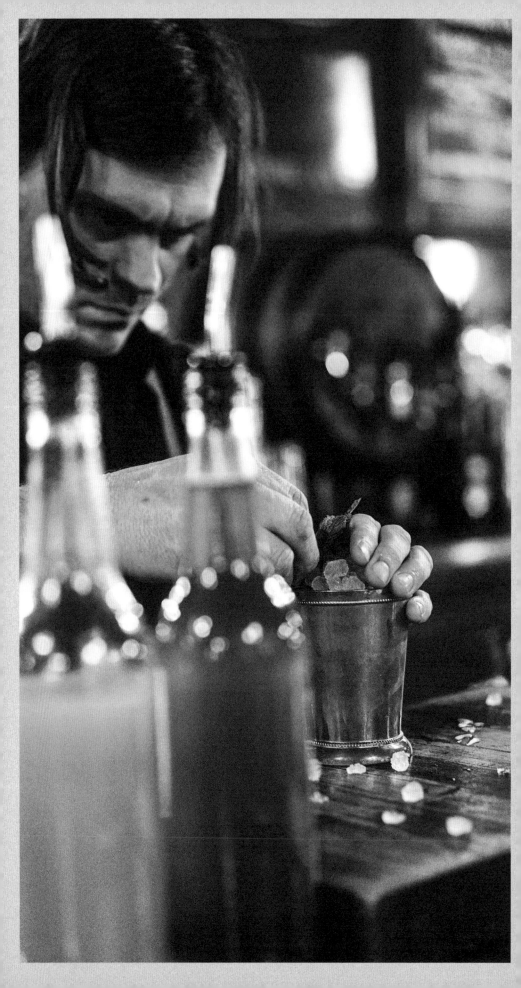

Mint Julep

Ingredients
- 2 oz. bourbon
- 0.5 oz. simple syrup
- 1 sugar cube
- Pinch of mint leaves

Directions
1 Muddle mint leaves and sugar in a highball glass.
2 Fill glass with ice, and add bourbon.
3 Stir until chilled.
4 Garnish with mint sprig.

Recipe courtesy of
Cole's French Dip
(page 58)

Harlowe
and
Sassafras

For a decade, the 1933 Group has been behind some of the most interesting new bars in town, combining a unique design aesthetic, an appreciation for Los Angeles history, and a commitment to creating "perfect drinkeries." They have a knack for finding great, neglected buildings with forgotten histories and transforming them into places that bring these old stories back to life. For them, a bar theme isn't something you pull from the sky; it's something that comes, ideally, from the actual site. Two of their bars, the **Highland Park Bowl** (page 104) and the **Idle Hour** (page 214) are examples of how historic properties can be successfully restored and reused, making preservation—and pre-Prohibition cocktails—part of modern culture. Angelenos, it's been proven, have a taste for both.

As co-owner Dimitri Komarov says, "With historic properties, there is a sense of nostalgia in the bones of the space, which innately transports people to another time and place." But when the building doesn't have a specific story that they can tap into, the 1933 Group is good at making it up. Designer and co-owner Bobby Green pays tribute to a personal hero—automobile racer, silent film player, and one-time saloon owner Barney Oldfield—with Culver City's Oldfield's Liquor Room, and seeks to recreate the glamour of Golden Age Hollywood with West Hollywood's **Harlowe**. Other times, Green goes with pure fantasy. His first bar was Atwater Village's Bigfoot Lodge (now known as the Bigfoot Lodge East), which seemed

Harlowe
7321 California Route 2
West Hollywood
harlowebar.com

Sassafras
1233 N. Vine St.
Hollywood
sassafrashollywood.com

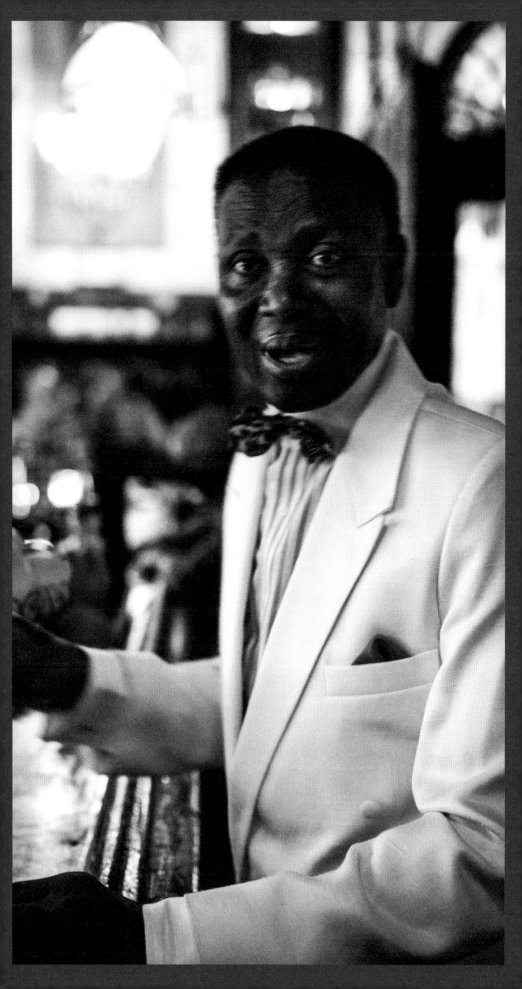

to take its cabin-like atmospheric inspiration from the original design of downtown's **Clifton's Cafeteria** (page 182), with a national-parks-on-steroids vibe and abundant taxidermy. (Although Green traces his inspiration to David Lynch's TV show *Twin Peaks*.) What could be more fantastic than a bar devoted to a mythological beast?

Similarly, **Sassafras** is a total fabrication, summoning up the spirit of the low country and mixing it up with an Old West saloon. The building itself is a reconstructed townhouse from Savannah, Georgia—so there's no real LA story here. Still, the 1933 Group not only does a stellar job with the conjuring, they stay true—even in Hollywood, which we all know can be the most Time Square-esque of areas—to what Green calls their overarching goal: to "create bars that people want to frequent that will become a mainstay gathering place for many years." He goes on: "We are inspired by the surrounding community. All of our bars are designed to create a sense of family and approachability." Oh, and there's live music and burlesque at Sassafras too.

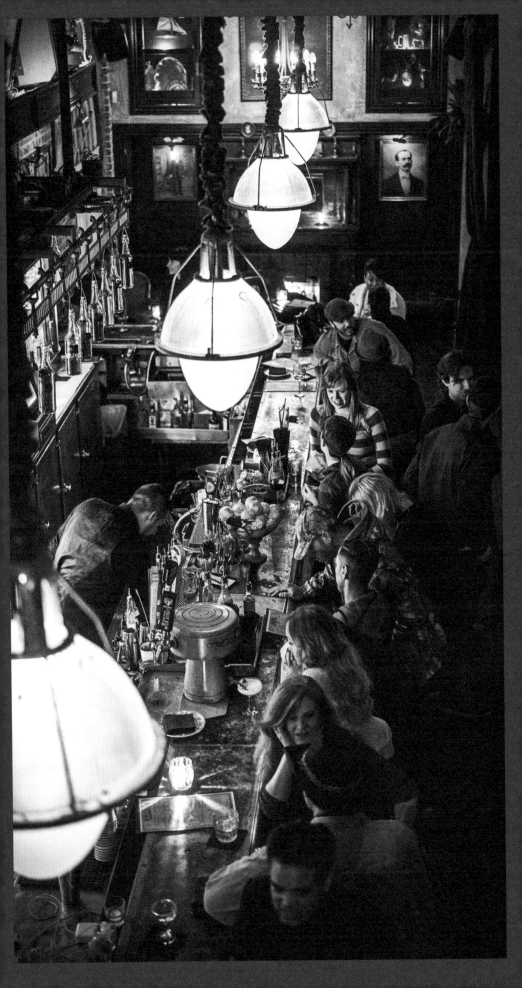

Sazerac

Ingredients
- 3 to 5 dashes Peychaud's bitters
- 0.5 oz. cane syrup
- 1 oz. Hine cognac
- 1 oz. Rittenhouse whiskey
- Lemon peel for garnish

Directions
1 Add ingredients into a pint glass with ice. Stir until cold.
2 Rinse a footed cordial glass with absinthe, and then strain Sazerac into glass.
3 Garnish with expressed lemon peel.

Recipe courtesy of
Sassafras
(page 70)

Baby's First Bourbon

Ingredients
- 2 oz. bourbon
- 0.75 oz. orgeat
- 0.75 oz. fresh lemon juice
- Angostura bitters
- Orange peel for garnish

Directions
1 Combine ingredients in mixing glass with ice and stir well.
2 Strain into tumbler glass with fresh ice.
3 Garnish with orange peel.

Recipe courtesy of
Harvard & Stone
(page 228)

Copa d'Oro

It's easy to be partial to this understated bar, which esteemed bartender Vincenzo Marianella oversees. First of all, it's close enough to the ocean that you can smell the sea air and find a quiet respite from the crowds and unhinged commercialism of the nearby Third Street Promenade. But the real reason to come to the **Copa d'Oro** is Marianella; and the real benefit of its location is its proximity to the biweekly Santa Monica Farmers Market, where Marianella often shops for inspiration for his coveted cocktails. Before opening the Copa, Marianella worked at the acclaimed restaurant Providence. He was known there for his innovative and exacting use of fresh ingredients in drinks that paired with the chef's seasonal tasting menu. His talent for creating delicious and creative cocktails was quickly noticed, and he became a cocktail consultant to many other well-known restaurants, including Manhattan Beach's Love & Salt; the nearby neighborhood favorite, the Independence; and the now-shuttered Doheny club.

Though he's not always behind the bar due to his busy consulting firm—and as a former semi-pro basketball player he cuts quite a figure there—Marianella's perfectionism and love for balance is evident in every cocktail. Named for what the Spanish explorers called California's native poppy flowers ("cups of gold"), the bar itself is dark and comfortable. The decor is nondescript in the right way so that the emphasis is where it should be: the drinks.

Copa d'Oro
217 Broadway
Santa Monica
copadoro.com

Smoke of Scotland

Ingredients
- 2 oz. Laphroaig Cask Strength whisky
- 0.5 oz. St. Germain
- 0.5 oz. Martini Extra Dry
- 2 bar spoons Averna
- Grapefruit peel for garnish

Directions
1 Combine ingredients.
2 Stir, and strain over large ice cube in rock glass.
3 Garnish with grapefruit peel.

Recipe courtesy of
Copa d'Oro
(page 78)

Vodka

"I have a punishing workout regimen. Every day I do three minutes on a treadmill, then I lie down, drink a glass of vodka, and smoke a cigarette." Anthony Hopkins

Campanula Sour

Ingredients

- 2 oz. grapefruit vodka
- 0.75 oz. St. Germain
- 0.75 oz. fresh lemon juice
- Dash of simple syrup
- 0.5 oz. cold-pressed red bell pepper juice (or muddle a bell pepper ring one-inch wide)
- 10 to 15 mint leaves

Directions

1 Combine ingredients in shaker, and shake.
2 Strain into cocktail glass.
3 Garnish with a thin slice of bell pepper.

Recipe courtesy of
Copa d'Oro
(page 78)

Live/Work

Ingredients
- 1 oz. vodka
- 1 oz. Aperol
- 0.75 oz. lemon juice
- 0.75 oz. simple syrup
- 3 to 4 basil leaves

Directions
1 Combine ingredients.
2 Shake, and strain on the rocks.
3 Garnish with basil.

Recipe courtesy of
Tony's Saloon
(page 158)

The Tam O'Shanter

Once upon a time, vodka was an exotic spirit (this was long before the invention of the appletini). As the legend goes, in order to encourage patrons to try it, John Martin, owner of the Smirnoff distillery, came to Hollywood's Cock'n Bull pub, where the owner happened to have an overstock of ginger beer. Similarly, some third party was in possession of too many copper mugs. Thus, the **Moscow Mule** (page 92), that refreshing and now-ubiquitous combination of vodka, ginger beer, and lime served over lots of ice was invented from unwanted and excess components. The result was a huge hit, and, while the Cock'n Bull is long gone from the Sunset Strip, the drink—and its signature copper mug, which gets so cold it feels as if it might cryogenically freeze your hand—are still popular. And no less an authority than Pulitzer Prize-winning food critic Jonathan Gold says the most authentic version of the Moscow Mule is served here, at the Scottish restaurant called the **Tam O'Shanter**.

Run by the same family for ninety years, the storybook-style building was constructed by film studio carpenters in 1922. Perhaps because it looks a bit like a dwelling suitable for seven dwarfs, Walt Disney and his animators often ate lunch here—his first studio sat just over the bridge in Silver Lake. For all the changes that can happen in a century, it is idyllic that a drink can live on, unmolested. It's almost the stuff of storybook tales.

The Tam O'Shanter
2980 Los Feliz Blvd.
Atwater Village
lawrysonline.com/tam-oshanter

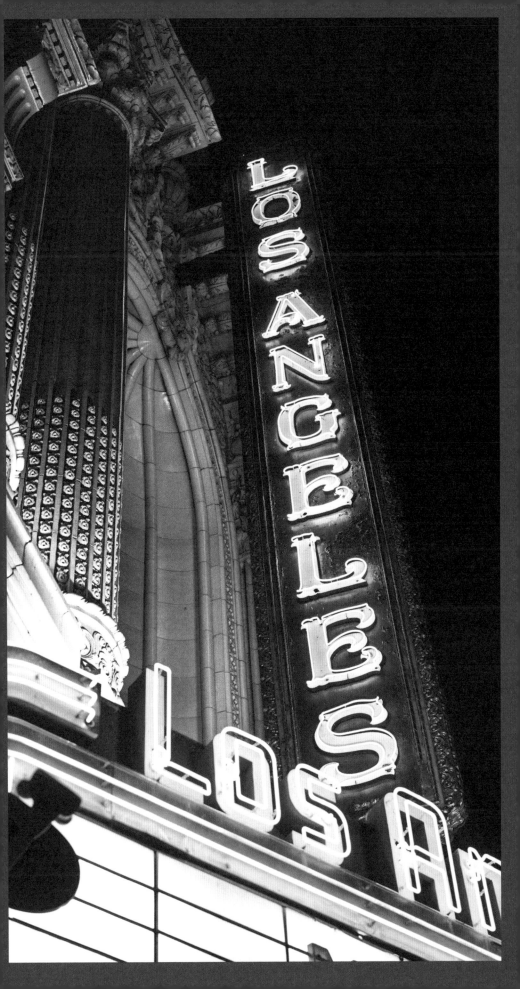

Moscow Mule

Ingredients
- 1.25 oz. Ketel One vodka
- 1 lime wedge
- 4 oz. Bundaberg ginger beer
- Lime wheel for garnish

Directions
1 Fill copper mug with ice.
2 Add vodka, squeeze in juice of one lime wedge.
3 Add ginger beer.
4 Garnish with one lime wheel.

Recipe courtesy of
The Tam O'Shanter
(page 90)

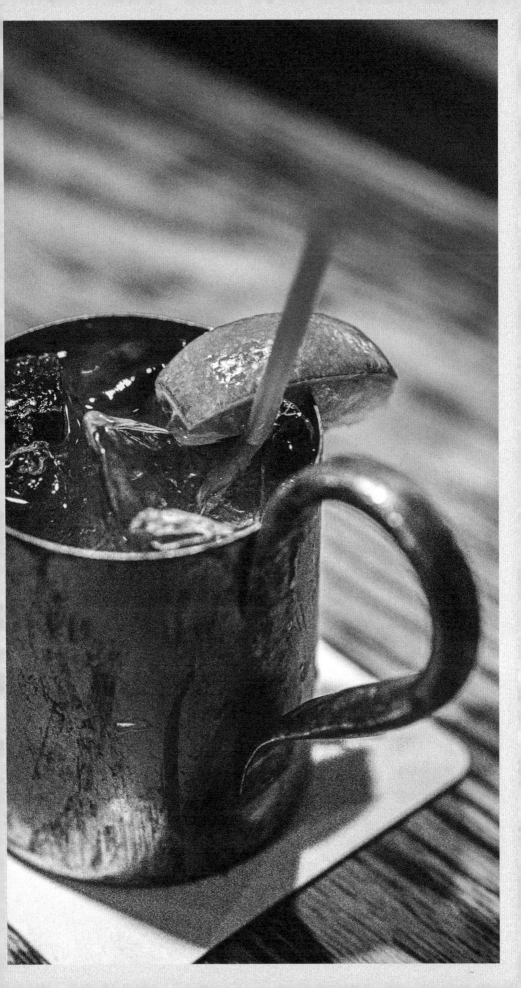

Boardner's

A true Hollywood watering hole, **Boardner's** has been operating just off the famed boulevard for seventy-five years. There's not much to look at from the street, save for the original, tilted neon sign, but inside is a place you can't reconstruct—one with the grime of decades of good times all over it. It is a bar with a background in bravado. If most places around Hollywood are Fitzgeraldesque recreations of deco splendor, this one skews more Hemingway: it's distinctive and direct, burnished by time into what LA writer Steven Mikulan once called, "a neighborhood bar in a town without neighborhoods."

Before Steve Boardner opened his namesake bar here in 1942, the Moorish-style space had already racked up several lifetimes of stories with runs as a theater, a beauty shop (which was probably a front), a nightclub owned by singer Gene Austin, a restaurant, and a gay bar. Then came Boardner at the right moment: Prohibition's end. People were ready to play. The action got rough and tumble since Boardner, a defender of the down-and-out and lover of the sporting life, drew a cast of hardscrabble characters to his bar, including boxers, card sharks, and wayward soldiers, who mixed with the hopeful ingénues, Hollywood working class, and, occasionally, filmdom's elite. Early film stars, such as Errol Flynn and noted alcoholic W.C. Fields, were what Boardner called "rounders," meaning they came around often.

Boardner's
1652 N. Cherokee Ave.
Hollywood
boardners.com

But the most notorious crime associated with Boardner's is the grisly—and still unsolved—Black Dahlia murder. In 1947, Elizabeth Short, a twenty-two-year-old aspiring actress who was also a rounder at Boardner's, was found murdered, her body severed in two at the torso. The press, sensationalizing the story, painted Short as a prostitute (she wasn't), and, over time, more than fifty people have confessed to the crime. Nicknamed the Black Dahlia, Short, and the mystery surrounding her murder, have been a part of LA lore ever since. It is rumored she was last seen here, although in official records police report her final sighting at downtown's Biltmore Hotel. Still, her presence at Boardner's is noted, and remains as a menu item—the cocktail named in her honor (page 96)—and possibly as a ghost said to haunt the women's restroom.

Yet here's a little sunshine chaser for all that noir: Ed Wood, the cult filmmaker from the 1950s, liked to drink here; and the bar is featured heavily in the 1994 film homage director Tim Burton made. It was an easy location to use since it didn't look that different from when Wood visited. So pick which side of pulp history you wish to summon: the tragic victim of a heinous crime or the individualistic B-movie auteur known for his love of angora. Either way, Wood's summary of Hollywood moviemaking continues to be prophetic: "Yes, but if you take that crap and put a star in it, then you've got something."

Black Dahlia

Boardner's likes to keep a little mystery to its drinks, so we've got the ingredients but not the measurements. You'll have to play to figure this one out, but we have no doubt the experiment will be worth your while.

Ingredients
- Godiva chocolate liqueur
- Stoli vanilla vodka
- Frangelico
- Chocolate for garnish

Directions
1 Combine ingredients.
2 Serve in a martini glass.
3 Dust with chocolate.

Recipe courtesy of
Boardner's
(page 94)

Bar Marmont

Though part of the legendary Chateau Marmont hotel, this cocktail lounge and restaurant is not actually located in the iconic hotel building—it's next door and decidedly easier to get into once the sun goes down. During the day, drinks at the hotel itself are lovely—enjoy them with lunch on the garden terrace with its idyllic views or inside, at the newly christened Hotel Bar, which has a secret menu for those in-the-know enough to ask.

But perhaps it's easier to forgo the hassle and drink among a slightly less-exclusive crowd (still gorgeous, still the chance to spot celebrities) next door. At **Bar Marmont** you will also find perfectly made cocktails, and you are still close enough to feel the haunting of the ghosts rattling around the gothic castle adjacent. Plus, the menu offers clever takes on the classics, including a Jerry Thomas Manhattan (rye whiskey, fresh lemon juice, sugar, grenadine, and absinthe) and the Ginger Rogers (gin, apple liqueur, fresh lemon and orange juices, meddled ginger root, and sugar). Perhaps the Marmont Mai Tai and a Havana Mojito would be more delicious if served poolside, but even those of us who can't afford a room at the Chateau can feel like a million bucks here; order the rich and creamy Millionaire (rye whiskey, fresh lemon juice, sugar, grenadine, and absente).

Bar Marmont
8171 Sunset Blvd.
West Hollywood (Sunset Strip)
chateaumarmont.com

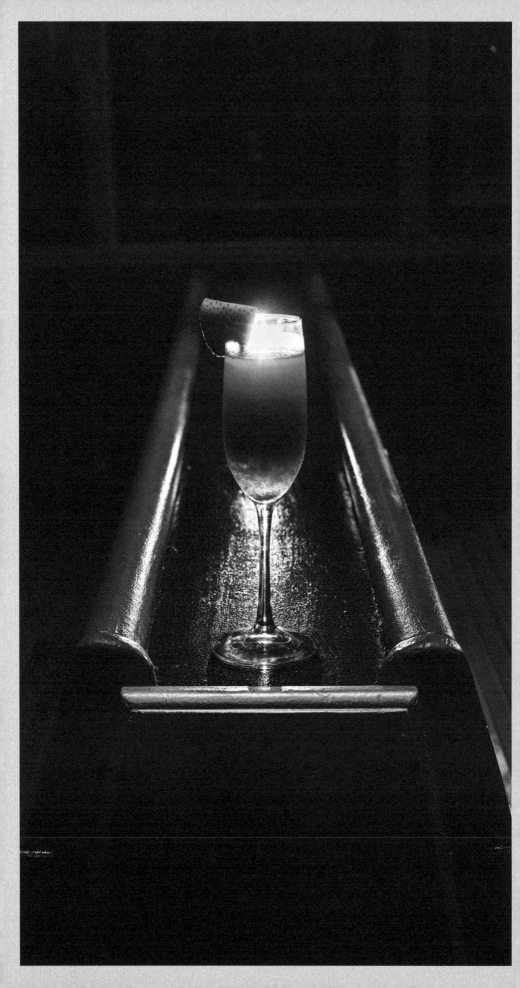

Moulin Rouge

Ingredients
- 0.5 oz. orgeat
- 0.5 oz. strawberry syrup
- 0.5 oz. Aperol
- 0.75 oz. lemon juice
- 1 oz. Absolut Elyx vodka
- 2 dashes of Peychaud's bitters
- Rosé champagne and strawberries for garnish

Directions
1 Combine ingredients.
2 Shake, and strain into a champagne flute.
3 Top with rosé champagne.
4 Garnish with a strawberry.

Recipe courtesy of
Pour Vous
(page 138)

Sex on the Bayou

Ingredients
- 0.5 oz. lemon juice
- 1 oz. SOB juice (equal parts lemon, orange, and cranberry juice)
- 0.5 oz. cane syrup
- 0.5 oz. strawberry basil balsamic shrub (*see recipe below*)
- 0.5 oz. Giffard pêche de vigne liqueur
- 1.5 oz. Absolut Elyx vodka

Directions
1 Add all ingredients to a shaker.
2 Shake, and strain into a collins glass.

Strawberry Basil Balsamic Shrub
Ingredients
- 1 cup chopped strawberries
- 1/2 cup sugar
- 1/2 cup water
- 1/4 cup balsamic vinegar

Directions
1 Add strawberries, sugar, and water to a pot, and bring to a slow simmer.
2 Simmer until the sugar is dissolved, stirring constantly to avoid burning at the bottom of the pan.
3 Allow to cool, and then blend until smooth.
4 Combine one cup of the strawberry mixture with the vinegar.

Recipe courtesy of
Sassafras
(page 70)

Highland Park Bowl

If you are of a certain age and live in Los Angeles, you've probably heard of Mr. T's, which was a much-beloved retiree bar and punk-rock club that operated in this space from the 1980s to early 2000s. Owned by and named for the proprietor of a nearby liquor store since 1966, the space was known for live music, as opposed to bowling, though the lanes were always there.

But before Mr. T, this site was the first iteration of the **Highland Park Bowl**, which dates back to the 1920s. When Bobby Green and his **1933 Group** (page 70) acquired the property in 2014, they decided to peel back the decades to revitalize the city's oldest bowling alley.

"We had no idea of what we would find," says Green. But as they removed the dropped ceiling and stripped back the layers, they found the building's stunning original architecture beneath a mid-century façade. "To our surprise, we discovered the magnificent Spanish revival architecture with a bow-truss ceiling and a mural painted in the 1930s," Green relays. That Arts and Crafts mural, which depicts a redwood forest, forms the backdrop to the eight restored lanes. The cavernous space feels warm and inviting, despite the size (and the skylights!), thanks to all the vintage decor and natural materials. It's an artful balance between the old and the new (computerized scoring), with a dash of steampunk for good measure. Everything they found while doing

Highland Park Bowl
5621 N. Figueroa St.
Highland Park
highlandparkbowl.com

the two-million-dollar restoration, they made use of: "Repurposing treasures we found that date back to the 1920s helps to give the space an overall historic feel and breathes life into the inherent soul," explains Green. Parts of the original bowling pin machines were turned into chandeliers that hang above the two horseshoe-shaped bars; old pins were transformed into lamps. Also on view, old bottles from the seventy-five cases of unused liquor Green found in the building's storage—they'd been there for well over forty years. Plus, there's a balcony over the lanes for watching the action; a front room bar called Mr. T's Room, where occasionally live-music acts perform; and a wood oven in the kitchen churning out Neapolitan-style pizza.

What about the drinks? They are a witty modernization of classics, many invoking stories from the building's past. **The Dude Abides** (page 106) is a White Russian riff that uses house-made coffee liqueur and horchata cream. The name references the title character in 1998's *The Big Lebowski,* which many would posit as the best bowling movie ever made. Similarly, **Owen Loves His Momma** (page 127), a tequila refresher with a nice hit of jalapeno, is another allusion to film; it's named for the 1987 cult comedy *Throw Momma from the Train,* some of which was shot in the old Mr. T's. Like many of LA's newer bars, Highland Park Bowl also offers several cocktails on draft, including the Eastside variation known as the **Belle of**

the **Bowl** (page 201), which features honeydew-infused gin and cucumber thyme soda.

The Dude Abides

Ingredients
- 1 oz. vodka
- 1 oz. Civil cold brew coffee Dude liqueur (*see recipe below*)
- 2 oz. horchata cream (*see recipe below*)
- Cinnamon stick for garnish

Directions
1 Blend ingredients.
2 Serve with a cinnamon stick garnish.

Dude Liqueur Recipe
- 4 parts cold brew concentrate
- 1 part demerara syrup (equal parts demerara sugar to water)
- 3 parts Zaya gold rum

Horchata Cream Recipe
Ingredients
- 5 L Rice Dream
- 8.5 oz. can Coco López
- 3/4 tbsp. gelatin
- 1 1/4 pieces large cinnamon sticks
- 1 cup sugar

Directions
1 Add Rice Dream, Coco López, and ground cinnamon sticks to Cambro.
2 Slowly stir in sugar and gelatin.
3 Apply stick blender until sugar is dissolved.

Recipe courtesy of
Highland Park Bowl
(page 104)

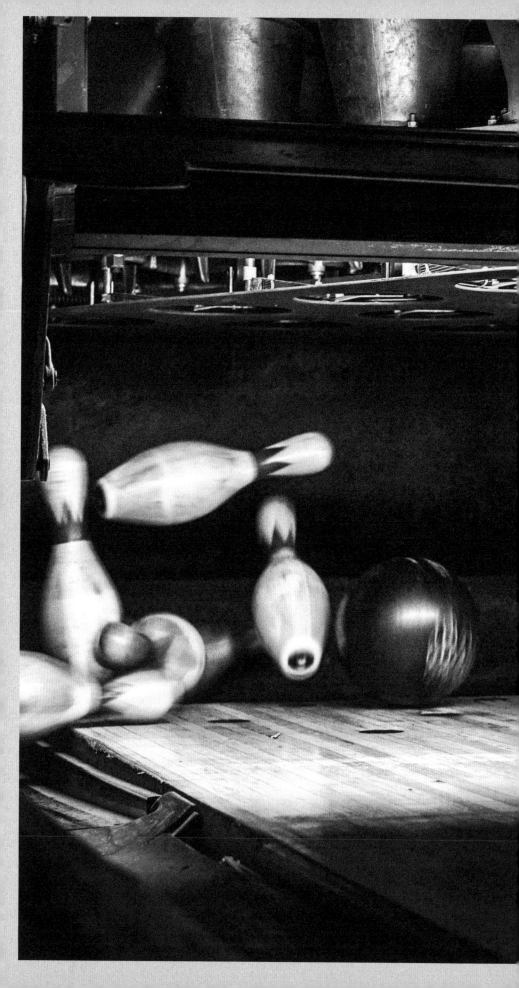

Mezcal/
Tequila

"A little tequila, sunshine, and tacos never hurt anybody."

Matthew McConaughey as Ron Woodroof in *Dallas Buyers Club*

El Compadre

The most decadent thing you can do in a city with weather as idyllic as LA's is to ignore it and opt to spend the day in the dark. **El Compadre**, a family-owned Mexican restaurant on Sunset Boulevard, will allow this. There are no windows inside—only a big bar and huge leather booths. No matter what time of day, it is dark as night inside, the only illumination being a few moody, old fixtures and the blue flame atop the famous **Flaming Margarita** (page 114).

These are not some fancy mixologist's version of the Mexican restaurant staple; the margaritas here, while delicious, are not pristine. No one was squeezing fresh juice for the drink in front of you. This restaurant is even part of a chain! But the margarita isn't pristine in its provenance either—there are so many accounts of its origin that any bastardization, is, well, acceptable. So get it frozen, with strawberries, or go the opposite direction and order it spicy. The important thing is you have found a spot where time stands still.

Unless it's a game day. Dodger Stadium is nearby, and El Compadre's proximity makes it the perfect place to celebrate a victory or soak away defeat. Baseball fan or not, the congeniality at the bar is as infectious as a cold. If you weren't cheering on the team when you walked in, you will be rooting for the Dodgers by the time the check arrives.

El Compadre
1449 W. Sunset Blvd.
Echo Park
elcompadrerestaurant.com

Flaming Margarita

This is the signature margarita served by El Compadre since 1975. The recipe is under lock and key.

(Note: Head straight to El Compadre for this tasty cocktail. If you're hankering to make a flaming margarita in the meantime, check out this recipe below.)

Ingredients

- 1.5 oz. tequila
- 1 oz. lime juice
- 0.75 oz. triple sec
- Lemon for garnish
- Coarse salt

Directions

1 Moisten the rim of the glass and apply coarse salt.

2 Combine tequila, lime juice, triple sec, and ice in cocktail shaker; and shake well.

3 Strain into rocks glass with fresh ice.

4 Float lemon slice on top of drink, add dash of tequila, and light the lemon slice.

Courtesy of
El Compadre
(page 112)

Bar 1886

If you can call a freeway charming, it would be the 110 North, which old-timers still call the Pasadena Freeway a rolling, six-lane road that snakes alongside the scenic Arroyo Seco and winds its way from downtown Los Angeles through Art Deco-adorned tunnels. Built in 1940, this is LA's first freeway (also, some argue, the first freeway in the U.S.), and it links the city to Pasadena, a somewhat sleepy suburban city to the northeast. Near the freeway's end, you will find the Raymond restaurant, which, like the freeway itself, is a relic from another era. When Pasadena was founded in the nineteenth century, it was a resort town for wealthy easterners seeking to escape the winters back home. The two-hundred-room Raymond Hotel (open only from November to May), featuring all the modern amenities of the time and surrounded by citrus groves, served as a residency of choice for these discerning vacationers. And while the city of Pasadena was "dry," the hotel had a not-so-secret bar in the basement poolroom. It's no wonder, then, that the hotel entertained luminaries such as Charlie Chaplin and Buster Keaton.

Today, the Craftsman cottage that houses the Raymond restaurant is all that remains of this palatial retreat, which, after suffering several fires, was demolished in 1934. This bungalow was once the hotel caretaker's home, although Walter Raymond, the proprietor of the hotel, lived here himself when his fortune turned during the Great Depression.

Bar 1886
1250 S. Fair Oaks Ave.
Pasadena
theraymond.com

Today the bar, named in honor of
the year the hotel was founded, is a
hidden gem. Opened in 2010, **Bar 1886**
defies the passage of time and retains
a residential feeling, as if you too
are one of the well-heeled easterners
here for an escape. The cocktail
program, created by Aidan Demarest
and Marcos Tello, harkens back to the
pre-Prohibition era as well, with classic
technique and hand-cut chunks of ice.
And though the leather benches and
cozy atmosphere seem of another era,
the craft is not frozen in time; instead,
the cocktail menu changes seasonally,
with witty plays on historic drinks
and characters—which is, of course,
fitting, given the place. Take Tello's
Medicina Latina (page 118), a tequila
riff on another modern cocktail (the
Penicillin): this gingery sipper will
cure what ails you, be it a nineteenth-
century case of tuberculosis or a post-
modern malaise mixed with seasonal
allergies. The jaunt to Pasadena is
worth it.

Medicina Latina

A variation of a Penicillin, created by Marcos Tello.

Ingredients
- 0.75 oz. fresh-squeezed lime juice
- 0.375 oz. clover honey syrup (Combine two parts clover honey with one part water.)
- 0.375 oz. fresh ginger syrup (Combine equal parts fresh ginger juice and sugar.)
- 2 oz. plata tequila
- Mezcal and candied ginger for garnish

Directions
1. Combine ingredients in cocktail shaker.
2. Shake for four to five seconds.
3. Strain ingredients over fresh ice (large rock preferably) into a tumbler.
4. Finish with a spray or float of mezcal and a candied ginger garnish.

Recipe courtesy of
Bar 1886
(page 116)

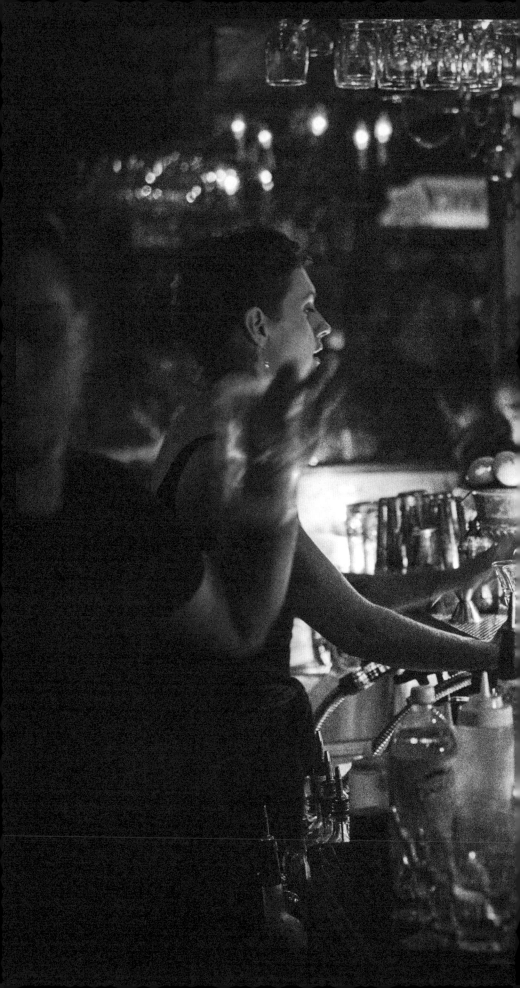

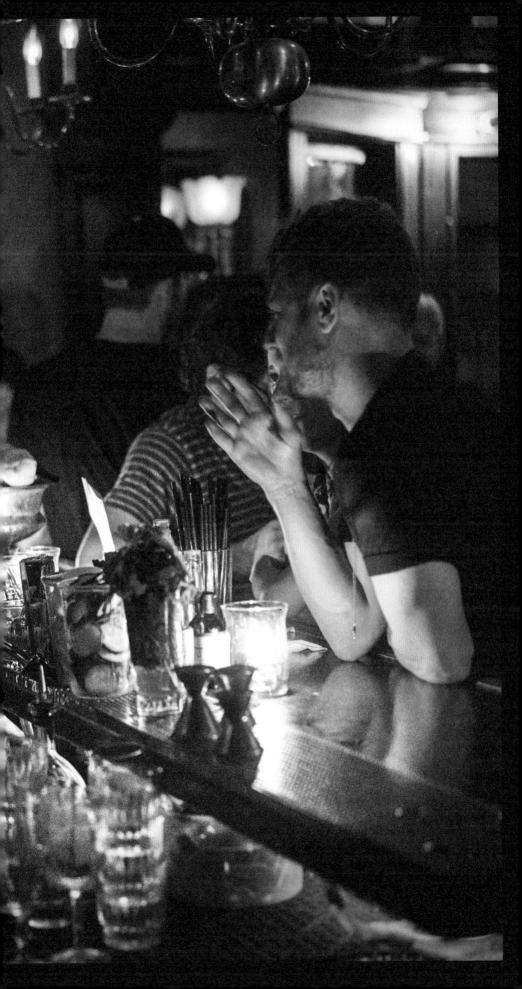

La Cita Bar

You will be forgiven if, walking by the faux-hacienda-style building boasting Mexican flags in its elaborate tile work, you mistake **La Cita** for a family-style Mexican restaurant; instead, it is a historic Mexican dance hall that today boasts a clientele as diverse as the city. Step inside the dark foyer and enter a microcosm of Los Angeles, where old-timers and newly arrived loft dwellers imbibe in buckets of beers, micheladas, and cocktails that take advantage of the bar's vast selection of tequila. Beneath colorful strings of lights is a long wooden bar that stretches along one side of the space; on the other side is a packed dance floor with a small stage and a fabulous mural of a bullfighter.

There is always music, traditionally of Latin heritage: norteño, ranchera, cumbia—but also, rockabilly, punk, and hip-hop. Depending on the night, the music changes, but the energy on the dance floor does not. For decades, people of all ages have been coming here to drink and to dance with earnestness and an openness that has inspired intermixing, not just of people, but also of musical styles.

Here, Mexico's most popular highball is prepared as it should be, with a Squirt soda. It is refreshing, both the drink and the view from El Patio, the bar's large, outdoor patio. Surrounded by downtown's looming skyscrapers, you have found a snug space, democratic and fun, in the middle of the city.

La Cita Bar
336 S. Hill St.
Downtown
lacitabar.com

Paloma

Ingredients
- 2 oz. tequila
- Grapefruit juice
- Grapefruit soda (Squirt)
- Ice
- Salt for rim
- Lime

Directions
1 Pour tequila into a glass, and squeeze in lime wedge.
2 Add ice and equal parts grapefruit juice and grapefruit soda.
3 Pour into shaker, and shake a few times.
4 Rim the glass with salt and pour in the contents of the shaker.
5 Garnish with a lime wedge.

Recipe courtesy of
La Cita Bar
(page 122)

Owen Loves His Momma

Ingredients
- 0.75 oz. hibiscus syrup (*see recipe below*)
- 2 oz. lightly-infused jalapeno silver tequila
- 0.5 oz. lime juice
- 0.5 oz. Chareau aloe liqueur
- IPA
- Edible flower for garnish

Directions
1 Shake liquor and juice until tin is chilled but not frosty. Don't beat up the ice.
2 Strain over fresh ice in tall glass.
3 Top with IPA.
4 Garnish with edible flower.

Hibiscus Syrup Recipe
Ingredients
- 2 cups hibiscus
- 5 cups water

Directions
1 Simmer for one hour, and then strain hibiscus.
2 Measure remaining liquid, and add equal parts sugar. Stir until dissolved.

Recipe courtesy of
Highland Park Bowl
(page 104)

Rum

"All
roads
lead to
rum."

W. C.
Fields

Daiquiri

Ingredients
- 0.75 oz. cinnamon syrup
- 0.75 oz. lime juice
- 0.5 oz. apricot juice
- 2 oz. El Dorado rum, aged three years
- 2 dashes of orange bitters
- Lime wedge and edible flower for garnish

Directions
1 In a mixing tin, combine apricot juice, lime juice, cinnamon syrup, rum, and orange bitters.
2 Fill with cubed ice, and shake long and hard.
3 Double strain into a chilled coupe glass.
4 Garnish with a lime wedge and an edible flower.

Recipe courtesy of
Pacific Seas at Clifton's
(page 182)

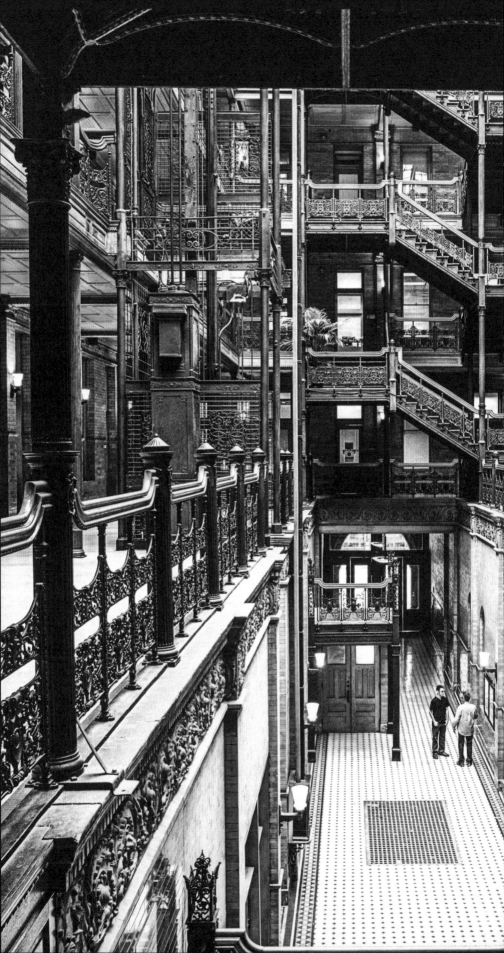

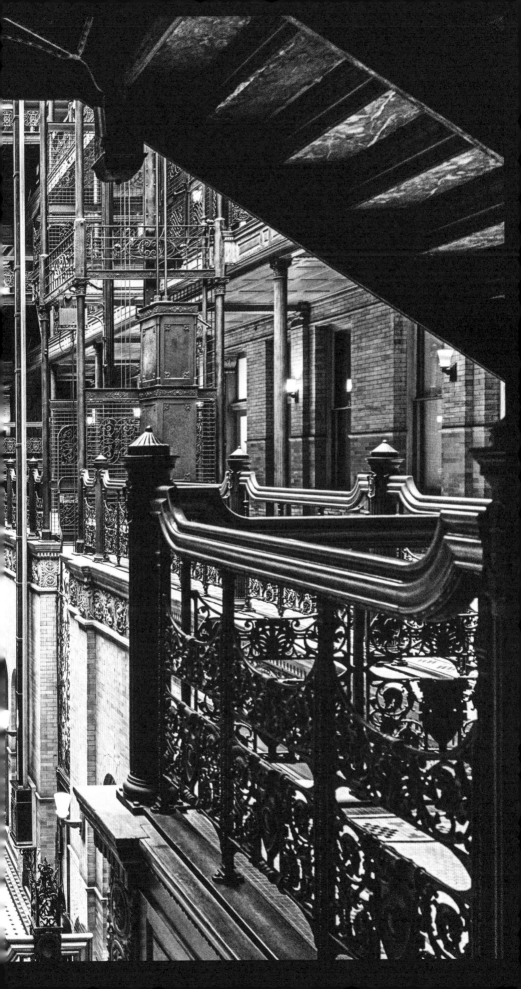

Reles Sour

Ingredients
- 1.5 oz. Mount Gay Black Barrel rum
- 0.5 oz. Mandarine Napoléon
- 0.25 oz. orange juice
- 0.5 oz. lime juice
- Egg white
- 0.5 oz. vanilla syrup
- Malbec reduction and orange zest for garnish

Directions
1 Shake, and fine strain into a sour glass.
2 Finish with a float of Malbec reduction and two orange zests.

Recipe courtesy of
The Edison
(page 36)

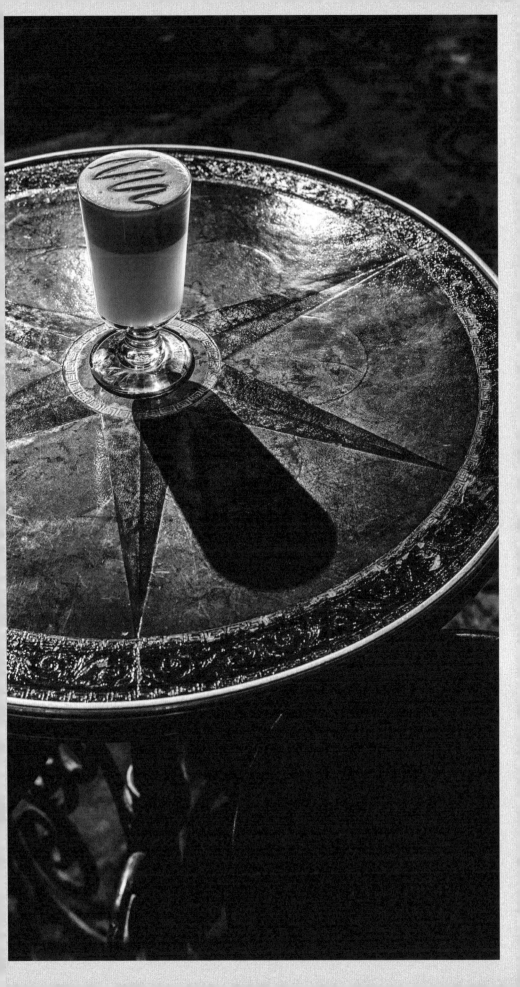

La Descarga, Pour Vous, and No Vacancy

Maybe it's because fraternal twins Mark and Jonnie Houston were born and bred near the neighborhoods where they've built most of their bars, or maybe it's because they grew up behind a bar—their mother ran a popular Koreatown dive bar—but these two seem to have an intrinsic knowledge of what Angelenos want in a bar, and they consistently deliver. In less than a decade, they've launched nine bars and a restaurant, each one different from the next but bearing telltale hallmarks that give the brothers' authorship away.

One of the duo's first bars was East Hollywood's **La Descarga**, a Cuban-themed rum and cigar bar opened in 2010. The bar has a neon sign in front of a battered old door; patrons walk up a flight of candlelit stairs to what appears to be the check-in of a dingy motel. An attendant checks your reservations and then a secret entrance opens up. And enter you do, on the slim, second-floor balcony above a raucous nightclub scene of people dancing below—across from you a quartet blasts cumbia music. Does this elaborate entrance ritual heighten the drama of what you discover inside? Certainly.

The surprise of the speakeasy-style entrance is just the tip of the iceberg as to the intricacy of the design inside: the ceilings and walls are weathered; the seating banquets covered in rich velvet; the bar itself is a beautiful marble. Next to the bar, and really throughout the dark, intimate space, people are dancing. (There are lessons on certain evenings). The live music is

La Descarga
1159 N. Western Ave.
East Hollywood
ladescargala.com

Pour Vous
5574 Melrose Ave.
Hollywood
pourvousla.com

No Vacancy
1727 N. Hudson Ave.
Hollywood
novacancyla.com

also sometimes accompanied by a show featuring burlesque dancers and fire. There's a back room—which, because it's open air, is where you can smoke cigars—that boasts a selection of nearly one hundred handpicked rums, served neat. Inside, at the main bar, pre-Castro cocktails dominate the menu, making use of heritage rum. The drinks and service are exemplary; there are no shortcuts taken on craft or courtesy.

It is a similar experience at **Pour Vous**, except instead of pre-Castro Havana this time it's Jazz Age Paris: the cocktails are a mix of well-constructed classics and house (maison) updates or inspirations from classics; the environment is immersive (a mini Grand Palais); and the crowd is civilized (dress code and reservations suggested). Also, like La Descarga, punch bowls are offered for larger parties, and there are shows featuring dancing girls (before the Houston brothers, this location was once Ivan Kane's Forty Deuce club).

Also in Hollywood is **No Vacancy**, an ode to gin in the form of a faded Victorian hotel—which is, in fact, the historic Janes House, the oldest home on Hollywood Boulevard. It's been lovingly redone by the Houstons, with elegant dark wood paneling and velvet tufted banquets and enclosed by a patio that features a glass garden house bar. Once again, there's a wonderful speakeasy-style entrance that incorporates a little movie magic (this is Hollywood after all) and gives the night a narrative of sorts to follow—

although taking it literally might spell trouble for you later.

Especially on Thursday, Friday, and Saturday nights, these bars can get crowded, with lines waiting to get in— even on off-nights, it's recommended guests make reservations. But even with that and the dress codes, these bars manage to feel unpretentious. And the quality of the experience they offer, both in terms of the cocktails and the transportive atmosphere, makes it worth a little bit of fuss. Because Houston brother bars are committed to carry out a theme so completely that you can't help getting taken away in it. Even when the bar at No Vacancy is four-people deep (and mind you, these are high volume bars), it still feels a bit like an adventure.

For as contrived as these bars are, they never feel like adult Disneyland. That's because amidst the artifice there's an underlying authenticity to the experience—there's no swindle to spending a long evening at La Descarga; you do feel you've been transported somewhere else. Maybe not Cuba, per se, but somewhere other than the place you just found a parking ticket waiting on your car's windshield. Going to a Houston Hospitality bar is like taking a tiny trip where you never physically—or even mentally—leave LA. You just see the best part of it for a while. How do they do it? Great cocktails, great art direction, and perhaps some serious affection for the hometown and the people who live—or just drink—here.

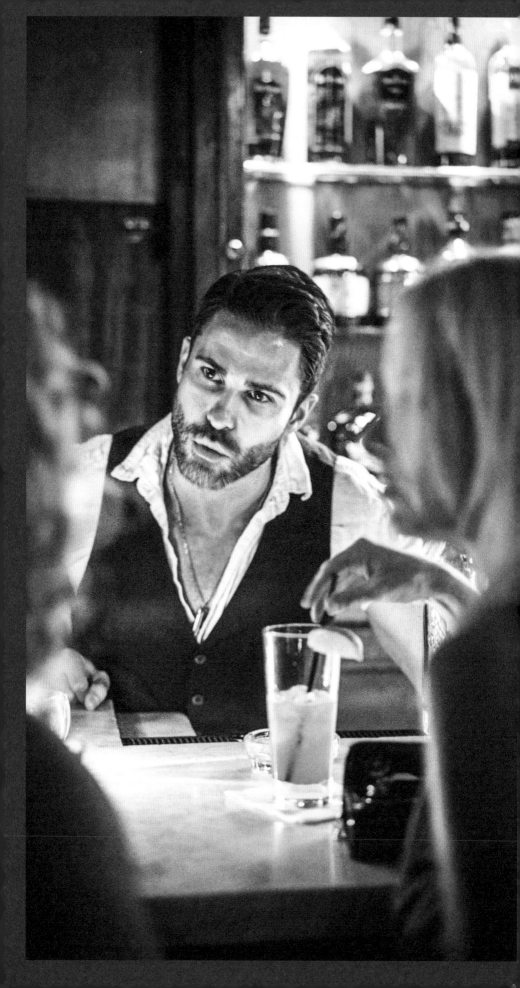

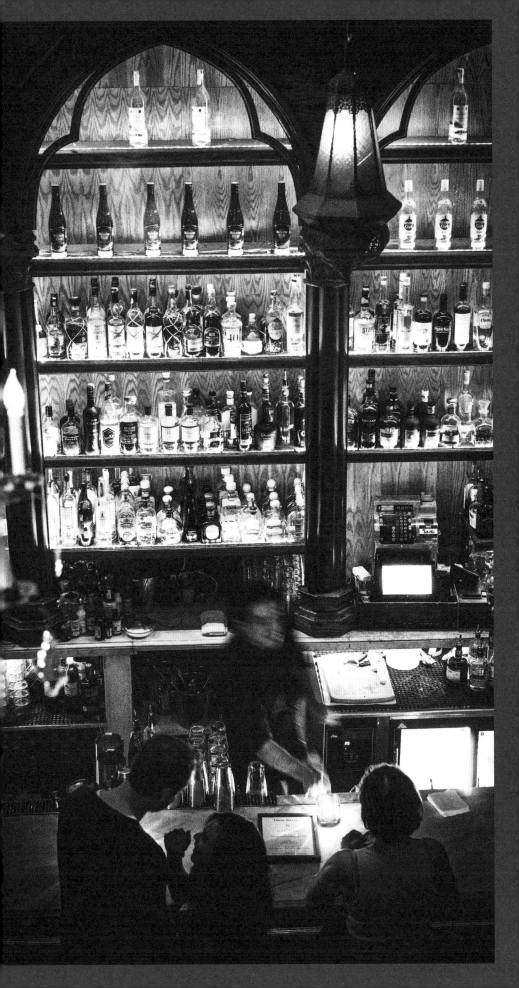

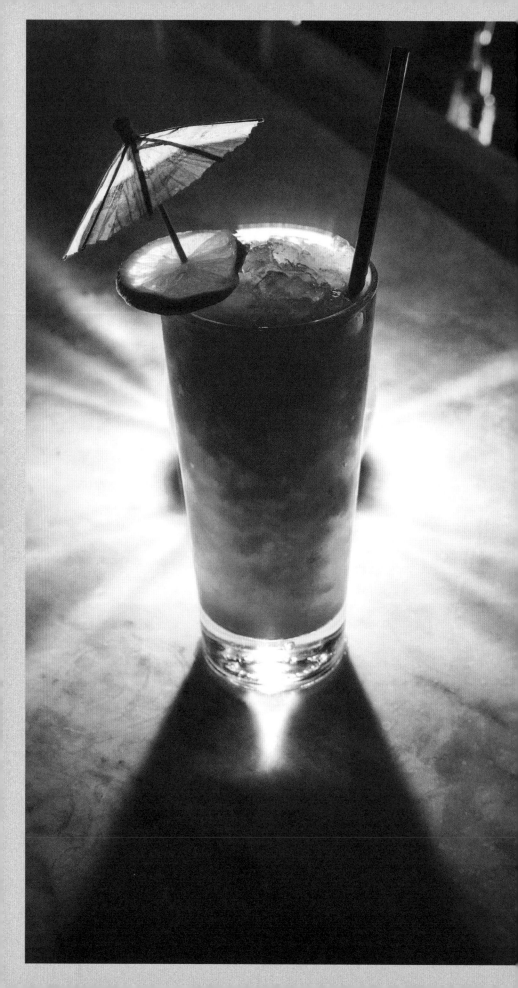

Siete Años

Ingredients

- 1.5 oz. mamey fruit (purée)
- 1.5 oz. Diplomático Añejo
- 0.5 oz. lime juice
- 0.5 oz. L'Orgeat liqueur
- Orange bitters
- Lime wheel and parasol for garnish

Directions

1 Combine ingredients, shake, and strain.
2 Serve over crushed ice in collins glass.
3 Garnish with lime wheel and parasol.

Recipe courtesy of
La Descarga
(page 138)

Tiki-Ti

What this diminutive bar—there are only twelve stools—lacks in size, it makes up for in legend. Everyone in LA knows the **Tiki-Ti**: it's one of the most beloved bars in town. Affection for the place runs deep, especially among long-time customers, whose names are part of the decor, pinned up on cards all over the ceiling under the heading of "Patrons of Rare Character." Opened by Ray Buhen in 1961, and run today by his son and grandsons, the "Tik" is not only a cultural treasure in LA, it's also a direct link, in terms of provenance, to Tiki's heyday. Before opening his own place, Buhen tended bar in the 1930s at Hollywood's Don the Beachcomber. Under the tutelage of its owner—the don of Don's—Buhen was there for the invention of several of the style's most popular drinks, including the Zombie, the Navy Grog, and the Gold Cup.

Buhen spent twenty-four years working the town's top Tiki bars, so when he started his own place, he brought years of experience and a direct connection to the origin of many tropical drinks. And because it's his descendants behind the bar today (and working the door), that link lives on; the Tiki's vast collection of cocktails has a pedigree—the **Zombie** (page 146) or mai tai you order here will likely be the closest you can find to the original drinks popular in the 1930s and '40s.

Tiki-Ti
4427 Sunset Blvd.
Los Feliz
tiki-ti.com

Like the drinks, the decor at the Tiki-Ti is pretty much unchanged since its opening in 1961, when much of the bar was built by Buhen. The small

space, filled to the brim with tribal
masks, hanging lanterns, glass fishing
floats, and old licenses plates, can get
claustrophobic when its crowded, so
it's best to go when the doors first open
at 4 p.m. (Wednesday through Sunday
only). While the extensive menu
offers ninety-four drinks, if you're
a first-timer you should disregard
ninety-three of them and start with
the signature drink, Ray's Mistake, the
recipe of which was a closely guarded
secret for years. As the name makes
clear, the cocktail was a happy accident.
Also, know that the mixing here is
often interactive; when a customer
orders a Blood and Sand, the entire
bar chants "Toro, toro, toro" while the
drink is topped off. Ditto on the Uga
Booga, which even the menu warns you
is "a very strong rum drink," inspiring
the crowd to chant, "Ooga booga."

Zombie

The Tiki-Ti likes to keep a little mystery to its drinks, so we've got the ingredients but not the measurements. You'll have to play to figure this one out, but we have no doubt the experiment will be worth your while.

Ingredients
- Simple syrup
- Lime juice
- Orange juice
- Passionfruit juice
- 151-proof rum
- Brandy
- Coruba dark rum for float

Directions
1 Shake all ingredients, except the dark rum, in a shaker with ice.
2 Strain into a collins glass filled with ice cubes.
3 Float the dark rum on top.

Recipe courtesy of
Tiki-Ti
(page 144)

The Galley

A rattan wonderland of nautical delights, the **Galley** is Santa Monica's oldest restaurant, and it's impossible not to be snared by it charms—and maybe also literally by the fishing nets hanging from the bamboo walls. Outside, a dinghy with a mermaid inside hangs over the entrance, flanked by neon waves. Inside, you will find, among the Christmas lights and sawdust-covered floors, the fabulous South Seas Bar, a near-perfect nautical fantasy where the drinks are stiff and the bartender sarcastic, which is as it should be. Between the Galley and **Chez Jay** (page 208), one wonders if all Santa Monica joints involve drunkenly emptying the pulverized wood out of your shoes after you leave.

Among the maximalist decor is memorabilia from the 1934 film *Mutiny on the Bounty*, including the ship's wheel that hangs from the ceiling, all gifted by the film's star and long-ago regular, Charles Laughton. There's also a great collection of World War II propaganda posters that makes you long, alongside your stout cocktail, for a government with more wit. First opened in 1934, today the Galley is owned by Ron Schul, a frequent patron and fan who bought the business in 1989. "Captain" Ron maintains that he bought the place so he could finally discover the restaurant's secret recipe for its salad dressing. Toss some of that on your greens as you toss down a mai tai at the bar and dream of foreign shores.

The Galley
2442 Main St.
Santa Monica
thegalleyrestaurant.net

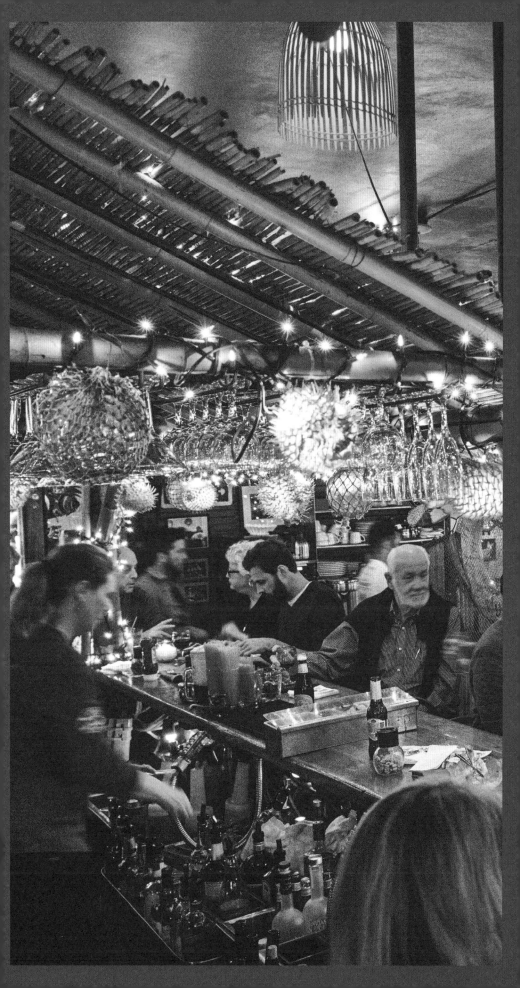

Mai Tai

Ingredients
- 2 oz. Mount Gay Black Barrel rum
- 0.5 oz. orange curacao
- 0.75 oz. fresh lime juice
- 0.5 oz. Liquid Alchemist orgeat
- Myers's dark rum
- Mint sprig and lime wedge for garnish

Directions
1 Combine ingredients and ice in shaker.
2 Shake, and strain onto crushed ice in a highball glass.
3 Float Myers's dark rum.
4 Garnish with mint sprig and lime wedge.

Recipe courtesy of
The Roger Room
(page 204)

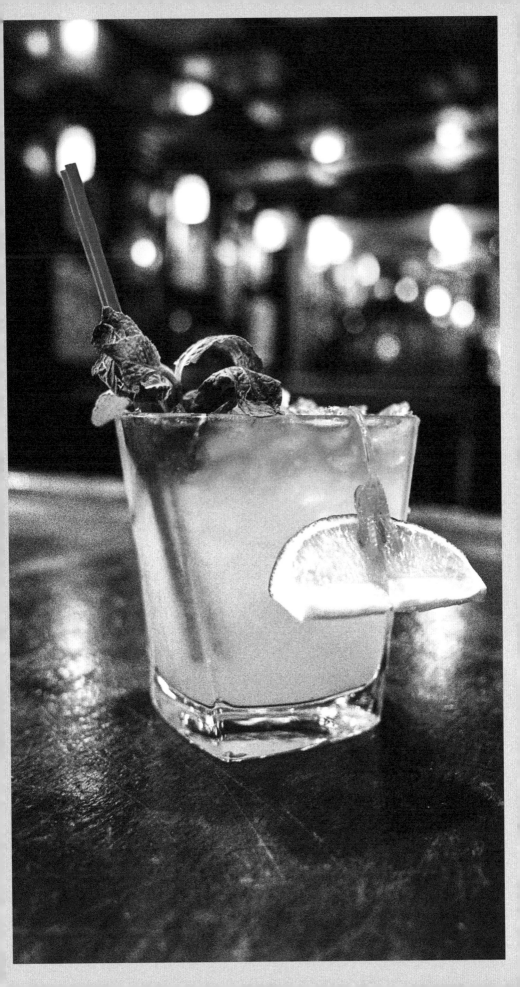

The Dresden Room

No one should leave Los Angeles without having spent an evening—preferably a long, late-night one—in the lounge of this still-sleek, mid-century restaurant and lounge. Walk through the nondescript entrance and find, on the restaurant side, a space fit for Don Draper, with white leather booths shaped like crescent moons and a time capsule "Continental" menu. On the opposite side is the lounge, the **Dresden Room**, with its cork- and faux-rock-covered walls. Drinks have been served here since 1954. The chairs around the tables are on casters, and each table features the bar's emblem in its center. All are clustered around a piano, which is where—at around nine o'clock five nights a week—the action really begins with Marty and Elayne, the veteran lounge singers who have a permanent residency crooning out jazz standards. The duo's act, which usually involves Marty on the drum kit or upright bass while Elayne tickles the ivories, is an unforgettable LA experience.

In case you didn't already realize it, this is one of the bars featured in the 1996 film *Swingers*, a movie that did a lot to reinvigorate retro-feeling bars in the neighborhood. What's wonderful about the Dresden Room is that it remains relatively unchanged by the acclaim—and seems immune to the passage of time in general. This is an admirable fate, and the bartenders here seem to feel similarly, embracing the vintage ambiance by wearing vests and emitting geniality behind the bar. For whatever reason, a blended **Blood**

The Dresden Room
1760 N. Vermont Ave.
Los Feliz
thedresden.com

and Sand (page 157) is the signature
cocktail here. Rumor is that Ray Buhen,
before he opened the **Tiki-Ti** (page
144), invented a tequila version of the
drink while tending bar here. (The
Tiki-Ti continues to offer the drink
with your choice of bourbon, scotch,
or tequila; and patrons shout, "Toro,
toro, toro," as the bartender tips it off.)
But the version served at the Dresden
Room today is rum-based, and on a
hot day, it's the equivalent of a boozy,
grown-up sno-cone. In other words:
perfect.

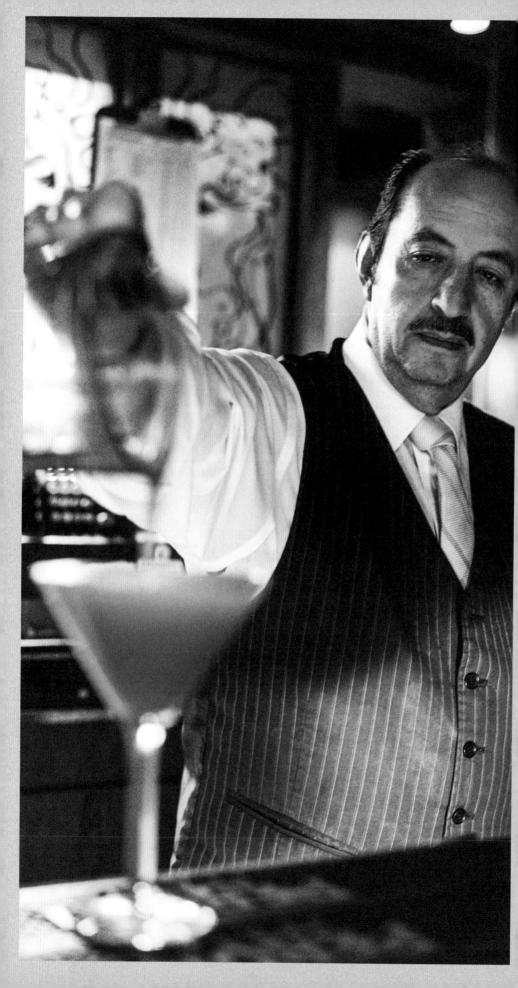

Blood and Sand

This rum-based variation was created by the original owner of the Dresden Room; its recipe remains secret. We can tell you this: it's served blended.

(Note: You'll want to visit the Dresden Room for this delicious, rum-based version. But in case you want to make a classic version yourself, see the recipe below.)

Ingredients
- 0.75 oz. single malt scotch whisky
- 0.75 oz. sweet vermouth
- 0.75 oz. cherry Heering liqueur
- 0.75 oz. orange juice
- Orange peel for garnish

Directions
1 Combine ingredients in a shaker and fill with ice.
2 Shake, and strain into a chilled coupe or cocktail glass.
3 Garnish with an orange peel.

Courtesy of
The Dresden Room
(page 154)

Caña Rum Bar and Tony's Saloon

It's possible that no one person has done more to repopularize cocktails in LA than Cedd Moses, founder and owner of 213 Hospitality (see **Cole's French Dip** and **The Varnish**, page 58; **Normandie Club** and **The Walker Inn**, page 224; **Seven Grand** and **Bar Jackalope**, page 28). During the last two decades, his acclaimed group has opened more than a dozen bars. In the process of doing so, Moses has played a key role in the revitalization of downtown. While he restored thriving businesses and nightlife to a neglected area, he simultaneously exposed a whole new generation to the wonders of a well-mixed cocktail.

In 2010, 213 Hospitality opened **Caña Rum Bar**, elevating one of the most maligned of spirits to a starring role. Boasting one of the largest collections of rum in the country, Caña is officially a private club, but as such it's pretty egalitarian—anyone can join for a twenty-dollar annual membership fee.

"The bars in LA, when I started, were either nightclubs insisting you buy bottle service or dive bars," says Moses. "I love dive bars, but there was an opportunity to just open spots with great booze, fair prices, and most importantly good hospitality. That's what a good bar is all about to me—friendly people."

And from his first bar—the Golden Gopher, a bar dating back to 1905 that Moses reopened in 2005—to his latest, Moses has stuck to the same formula: find a historically significant building

Caña Rum Bar
714 W. Olympic Blvd.
Downtown
canarumbar.com

Tony's Saloon
2017 E. 7th St.
Downtown
tonyssaloon.la

and reinvigorate the space by opening the type of bar that brings in locals and creates a destination.

A perfect example of such would be **Tony's Saloon**, opened in 2009 in the very happening Arts District. It was a dive bar before Moses moved in, and his team did seemingly little to change that except that they did everything to change it. As imagined by 213 Hospitality, Tony's is a "revamped roadside saloon," which means it has some dingy, worn decor, taxidermy, and Miller beer on draft; but this is all part of an executed vision, not happenstance. Still, just as the warm wood and low light have been thought about to create the right, timeless, and relaxed atmosphere, so too have other aspects of the bar. There are all the hallmarks of a classic neighborhood bar: pool, darts, even a ping-pong table on the back patio. Plus, the cocktails are equally thoughtful, crafted with fresh ingredients and featuring 213's Penny Pound Ice. The result of all this care is a *better*-than-neighborhood bar that still feels like, well, a neighborhood bar. Because that is the art of what 213 Hospitality does with most of their places: they create bars that still feel real, while also managing perfection.

It is rumored that the original dive bar located here ran numbers for horse races, which is why writer Hunter S. Thompson was an occasional guest. There's a little diorama devoted to him at Tony's Saloon, so in his words: "Buy the ticket; take the ride."

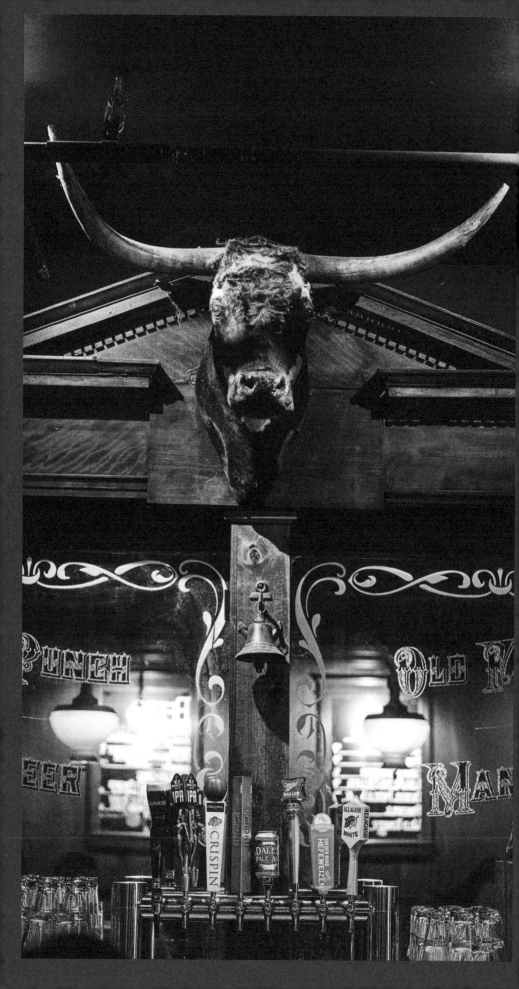

Brazilian Necktie

Ingredients

- 2 oz. Ypióca Prata cachaça
- 3 serrano peppers
- 1 Anaheim pepper
- 1 oz. lime juice
- 0.75 oz. simple syrup
- 5 cucumber wheels
- Smoked sea salt and black pepper for garnish

Directions

1. Infuse the cachaça with three chopped Serrano peppers and 1 Anaheim pepper. Let it sit for an hour or two, or until desired spice, and strain the chili peppers out.
2. To create the simple syrup, combine equal parts sugar in the raw with hot water. Stir until all sugar crystals have dissolved.
3. Muddle cachaça, lime juice, simple syrup, and cucumber; and shake with ice.
4. Pour into double old-fashioned glass.
5. Add pinches of smoked sea salt and black pepper.

Recipe courtesy of
Caña Rum Bar
(page 158)

Gin

"I like to have a martini/ Two at the very most/ After three I'm under the table/ After four I'm under my host." attributed to Dorothy Parker

Frolic Room

We all have our opinions on the matter, but to me the best dive bar in all of Los Angeles is the **Frolic Room**; it might also be the last true dive bar in Hollywood, and, for that reason alone, you should go. Located on Hollywood Boulevard, right next to the beautiful Pantages Theatre and spitting distance from the famous Hollywood and Vine intersection, the Frolic Room is a quaint reminder that Hollywood once was rough, not just around the edges, but also in its very heart. Before all the redevelopment of the last two decades, instead of lofts and chain stores, you'd find many more cheap souvenir shops, trashy boutiques, and head shops. Sure, there's still some seediness on the Boulevard, but it has certainly lost its bite.

The Frolic Room was around before all that though. It's thought that the bar was originally a private speakeasy that served players from the Pantages next door (the stunning Art Deco movie palace occasionally hosted live vaudeville as well). Allegedly overseen by a man named Freddy Frolic, the bar opened to the public after the end of Prohibition in 1934. Like nearby Boardner's, it's often rumored to be the last place the Black Dahlia was seen before her disappearance (not true). Also, unlike many bars around that claim Charles Bukowski sightings, the writer did actually drink here (there's a portrait of him above the register).

Frolic Room
6245 Hollywood Blvd.
Hollywood

Along with the iconic neon sign out front, the intimate interior features a 1963 mural by Al Hirschfeld, featuring

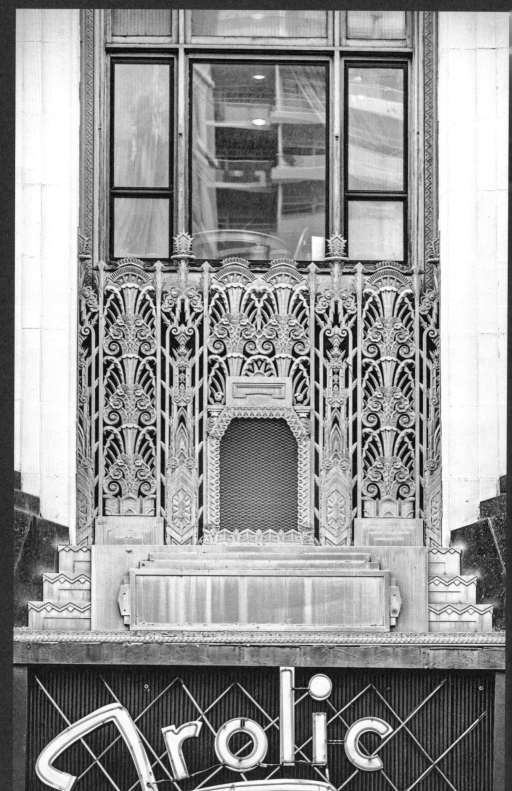

Hollywood stars, done in his signature style, and kept safe behind Plexiglas on the right wall; the long bar on the left. There are red bar stools for seating, a good jukebox, and moody lighting from the atomic-era lights overhead. You might recognize the place from film—Cassavetes's *A Woman Under the Influence* shot a scene here (Gena Rowlands picking up a guy at the bar), as did *L.A. Confidential.* The crowd is diverse: from tourists to long-time regulars who, especially during the day when the bar is quiet, prove to be characters. The people who work here, from the guy working the door to the bartenders, have seen it all, and, for the most part, remain amused. They are friendly, provided you stick with the program—and that doesn't mean a *cocktail* program. You are not here for mixology; you are here for a simple, stiff drink—a martini, a gin and tonic on a hot day, or a bottled Budweiser. This is not the place for shrubs or infusions; ordering a sherry cobbler would get you kicked to the curb. Open at 11 a.m., every day.

Dirty Martini

According to the Frolic Room bartender: "Mix gin with some olive juice; what can be easier than that?" (In case that isn't enough information for you, we've provided a classic recipe below.)

Ingredients
- 2 oz. gin
- 0.5 oz. dry vermouth
- 0.5 oz. olive brine
- Green olives for garnish

Directions
1 Combine ingredients in a mixing glass filled with ice.
2 Stir, and strain into chilled martini glass.
3 Garnish with olives.

Courtesy of
Frolic Room
(page 168)

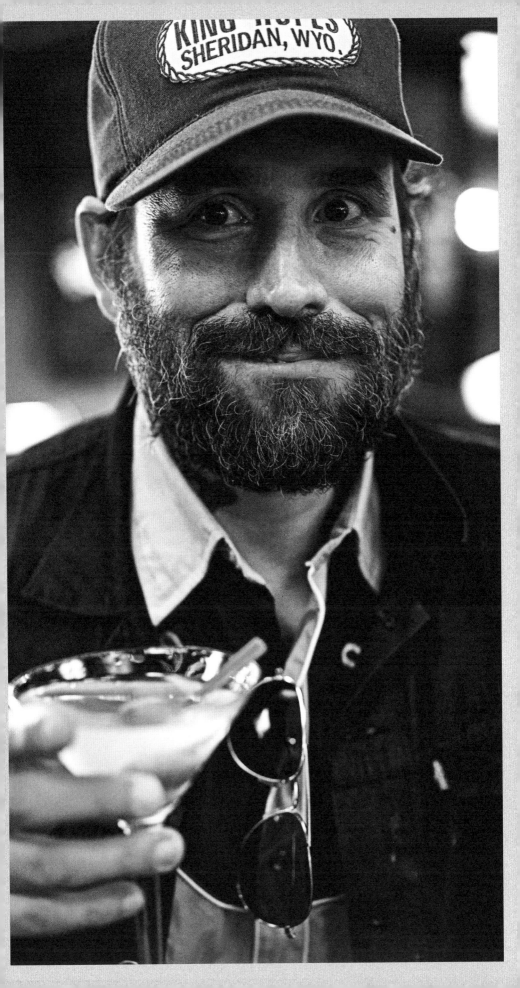

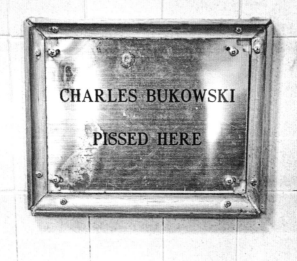

CHARLES BUKOWSKI

PISSED HERE

Gin Maid

Ingredients
- 2 oz. gin
- 0.75 oz. simple syrup
- 0.75 oz. lime juice
- 4 cucumber slices
- 6 mint leaves
- Extra cucumber slices for garnish

Directions
1 Muddle cucumber slices with simple syrup and lime juice.
2 Add gin, mint, and ice; shake long and hard.
3 Strain into a coupe glass, and garnish with a cucumber slice.

(Traditionally done on the rocks with a cucumber/mint flag, however, it was requested up—aka an Eastside—for the photograph.)

Recipe courtesy
of Harlowe
(page 70)

Watercress Martini

Ingredients
- 1.5 oz. watercress Fords gin
- 0.5 oz. Absolut Elyx
- 0.75 oz. Dolin dry vermouth
- 0.25 oz. Dolin blanc vermouth
- 1/2 tsp. Giffard pêche liqueur
- 1 drop salt
- Cut pickles for garnish

Directions
1 Stir together ingredients, and strain.
2 Pour into cocktail glass and dividends beaker.
3 Garnish with cut pickles.

Recipe courtesy of
The Walker Inn
(page 224)

Clifton's

Before it was purchased and restored in 2012 by Andrew Meieran, **Clifton's**, known then as Clifton's Brookdale, was the last outpost of the region's largest cafeteria chain, owned by visionary restaurant and social reformer Clifford E. Clinton. Clinton's thematic restaurants—one was devoted to the Pacific seas, this one to California's famous redwood forests—were not only aesthetically stunning in the thoroughness of the immersive design, but also socially conscious. During the Depression, Clinton instituted a "pay what you wish" policy; among the notable people who took use of it were writers Ray Bradbury and Charles Bukowski (appropriately, Clifton's is mentioned in his novel *Ham on Rye*).

After eighty-two years serving Jell-O salad in a full-blown replica of a forest—complete with a waterfall and stream—Clinton's descendants decided to sell to Meieran, the same developer who created the **Edison** (page 36). Not wanting to lose the fantastic forest design, which is credited as partly inspiring Walt Disney, a frequent patron, to create Disneyland, Meieran doubled down, preserving some of the interiors and reimagining the massive space. He added five bars, each of which is to have a distinct identity. Consultants on the project included two of LA's top barmen, Michael Neff and Damian Windsor (**The Roger Room**, page 204); and so far, three of the bars are up and running: the mezzanine Monarch Bar (devoted to local beers and spirits); the second-floor Gothic Bar; and the Pacific Seas (a "pan-

Clifton's
648 S. Broadway
Downtown
cliftonsla.com

Polynesian bar" on the fourth floor).

Though the former cafeteria has been transformed into a hipper, and much darker, "cabinet of curiosities," each of the bars stays tied to Clifton's former glory by either highlighting historic artifacts (the Pacific Seas has objects from Clifton's original Pacific Seas, as well as from other legendary departed Tiki bars) or by paying homage to the events and people who once ate their meals off the now-iconic cafeteria trays.

The Gothic Bar, for instance, pays tribute to the science fiction writers who used to meet in the Brown Room during the 1930s—including Bradbury, Scientology founder L. Ron Hubbard, and the great monster movie aficionado, Forrest J. Ackerman—with a giant meteor. As Robert Clinton the son of one the original owners, once told the *Los Angeles Times* of these men, who formed a Science Fiction club that met weekly and remains in operation today (although they no longer meet here): "They dreamed of the future, and many of those dreams came true."

The same might be true for Meieran, who is still working on the other two bars he's dreamed up: one, a high-end cocktail lounge at the top of the building called Treetop; the other a basement level speakeasy called Shadowbox, which he's hyping as the most revolutionary cocktail experience on the planet.

Singapore Sling

Ingredients

- 0.25 oz. Bénédictine
- 0.25 oz. simple syrup
- 0.5 oz. cherry Heering liqueur
- 1 oz. pineapple juice
- 0.75 oz. lemon juice
- 1.5 oz. Aviation gin
- 1 dash orange bitters
- 1 dash Angostura bitters
- 1 oz. soda
- Lemon wedge and umbrella for garnish

Directions

1 In a mixing tin, combine simple syrup, lemon juice, pineapple juice, Bénédictine, cherry Heering liqueur, gin, and orange and Angostura bitters.
2 Fill a mixing tin with cubed ice, and shake medium hard.
3 Strain into a footed pilsner filled with cubed ice.
4 Garnish with a lemon wedge and umbrella.

Recipe courtesy of
Pacific Seas at Clifton's
(page 182)

Musso & Frank Grill

There is no better place to get a Martini (page 192) in Los Angeles than this venerable Hollywood institution—the oldest restaurant in Hollywood, open since 1919. The same family has owned Musso's since 1927, and when you slide up to the mahogany bar in the New Room (at more than sixty years old, it hasn't actually been new since replacing the famous Back Room in 1955), you are getting a drink with almost a century of knowledge behind it. And you might notice that the gentleman serving it to you is similarly aged to perfection: two of the long-time bartenders, Manny Aguirre and Ruben Rueda, are like other members of the family, a vital connection to its storied past. These men, clad in the trademark red bolero jackets and bow ties, are ambassadors to another time, when multiple martinis were had at lunch. Here at Musso's, they can be gin or vodka, of course, and are always a perfect three ounces, served with a chilled decanter on the side. It is an elegant drink in a singular setting: a true taste of classic LA.

So who else imbibed here? The better question is: who of note in the twentieth century didn't? Birthed at basically the same time as film stars, they all came here to eat: the titans of the silent era (Charlie Chaplin, Mary Pickford, Rudolph Valentino); the Golden-era stars (Bogart, Bacall, Garbo); and Hollywood legends (Marilyn Monroe, Elizabeth Taylor, Steve McQueen). Whatever the decade, the bigwigs of the entertainment industry ate here, made deals here, and drank

Musso & Frank Grill
6667 Hollywood Blvd.
Hollywood
mussoandfrank.com

City of Los Angeles
State of California

RESOLUTION

WHEREAS,

Musso & Frank Grill

WAS FOUNDED IN 1919 AND HAS BEEN NOURISHING HOLLYWOOD RESIDENTS AND VISITORS FOR 70 YEARS; AND

WHEREAS, MUSSO & FRANK IS THE OLDEST SURVIVING RESTAURANT IN HOLLYWOOD; AND

WHEREAS, A TRUE MUSSO FAN CAN RECITE FROM MEMORY THE DAILY SPECIALS, WHICH HAVE REMAINED UNCHANGED FOR DECADES: MONDAY, CHICKEN AND NOODLES; TUESDAY, CORNED BEEF AND CABBAGE, AND SO ON; AND

WHEREAS, MUSSO & FRANK WAS A SECOND HOME TO SUCH LITERARY GREATS AS WILLIAM FAULKNER, NATHANIEL WEST, JOHN FANTE, THOMAS WOLFE, F. SCOTT FITZGERALD, AND WILLIAM SAROYAN, WHO STAKED A CLAIM TO THE BIG TABLE IN THE BACK ROOM; AND

WHEREAS, MOVIE STARS SUCH AS MARY PICKFORD, CLAUDETTE COLBERT, BETTE DAVIS, CESAR ROMERO, EDWARD G. ROBINSON, H.B. WARNER, CHARLIE CHAPLIN, AND MACK SENNETT ALSO CAME TO MUSSO & FRANK FOR THE IMPECCABLE MARTINIS AND THE FRENCH BREAD, UNEQUALED IN LOS ANGELES; AND

WHEREAS, THE MENU REMAINS SIMPLE AND TRUE TO TRADITION, AND MUSSO STILL SERVES THE FLANNEL CAKES MADE FAMOUS BY ITS ORIGINAL CHEF, JEAN RUE, WHO DIED IN 1976 AFTER 53 YEARS AS CHEF; AND

WHEREAS, MUSSO STILL MAINTAINS A DIGNIFIED AND ELEGANT PRESENCE ON HOLLY-WOOD BOULEVARD AND IS A TIE TO HOLLYWOOD'S PAST AS WELL AS A PART OF ITS VITAL PRESENT:

NOW, THEREFORE, BE IT RESOLVED THAT THE CITY COUNCIL OF THE CITY OF LOS ANGELES, BY ADOPTION OF THIS RESOLUTION, CONGRATULATES OWNERS EDITH CARISSIMI AND ROSE M. KEEGEL ON THE 70TH ANNIVERSARY OF MUSSO & FRANK GRILL.

RESOLUTION BY

Councilman 13th District

SECONDED BY

Councilman 4th District

ATTEST:

City Clerk

I HEREBY CERTIFY that the foregoing resolution was adopted by the Council of the City of Los Angeles at its meeting held June 23, 1989.

President of the Council

here. To this day, you can continue
to find celebrity patrons dining in
Hollywood's de facto clubhouse—only
nowadays they aren't whisked away to
the private Back Room. Instead Keith
Richards, Scarlett Johansson, and
Johnny Depp might be in the booth
next to you, or even perched at the bar.
And then there's the literary history:
with the Stanley Rose bookstore once
located nearby, Musso's drew F. Scott
Fitzgerald, William Faulkner (who
mixed his own mint juleps behind the
bar), and Raymond Chandler. Plus, T.S.
Eliot, William Saroyan, Aldous Huxley,
John Steinbeck, John O'Hara, and even
Dorothy Parker drank here. And later,
a new generation of writers found
their way to Musso's too, inspired by
the greats who'd come before: Joseph
Heller, Kurt Vonnegut, and, yes, even
Charles Bukowski. Finally, here's a bar
he wasn't just rumored to have visited;
he actually did.

Martini

Ingredients
- 1.5 oz. dry London gin (preferably Beefeater)
- 0.5 oz. dry vermouth (preferably Lillet Blanc)
- 2 pepper-stuffed olives for garnish

Directions
1 Stir, not shake, in a shaker only half-filled with ice for about thirty seconds.
2 Strain into martini glass with two pepper-stuffed olives.

Recipe courtesy of
Musso & Frank Grill
(page 188)

Dan Tana's

An institution since 1964, this restaurant caters to its regulars—in fact, you'll find their names (most are famous) all over the menu items. While newcomers are made welcome, don't expect a seat without a reservation; and don't expect to get a reservation for primetime unless you're a celebrity—or someone in your family has a name on the menu. Still, **Dan Tana's** is worth visiting because it's real in its retro; and it's kind and convivial. The bar, especially after work, is filled with friends shouting to each other, and the drinks are well-made classics that harken back to the mid-century: martinis and manhattans.

While it may look like a typical red-sauce Italian restaurant—red-and-white-checkered tablecloths and Chianti bottles hanging from the ceiling—Dan Tana's is anything but ordinary. First, there's the history: back when few places in Hollywood were open past ten o'clock, Dan Tana's offered dinner late, to the benefit of many of the bands that played the nearby Troubadour and came here to dine afterwards. Along with the musicians, it's been a favorite with film folk for years (Clint Eastwood, Steve Martin, and George Clooney are fans; Drew Barrymore had her diaper changed in the bar). But the thing about Tana's that really makes the difference is the mix: you can be a famous somebody or you can be an absolute nobody; it doesn't matter. You will have a good time and be served by a gentleman in a red jacket with half a century's worth of experience.

Dan Tana's
9071 California Route 2
West Hollywood
dantanasrestaurant.com

Negroni

Ingredients
- 1 oz. Botanist gin
- 1 oz. Carpano Antica
- 1 oz. Campari
- Orange peel for garnish

Directions
1 Build in bucket glass with high-density cubes.
2 Stir, and garnish with orange peel.

Recipe courtesy of
The Roger Room
(page 204)

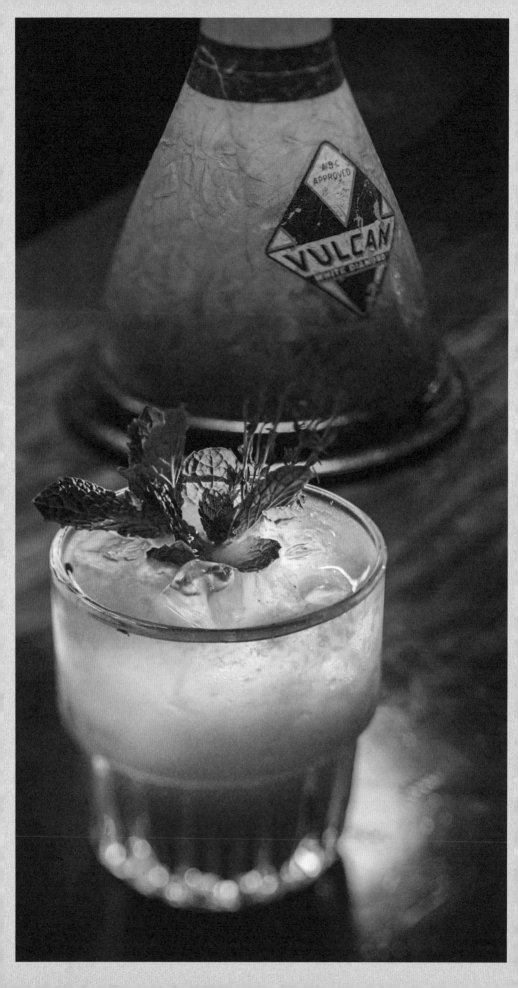

Belle of the Bowl

Ingredients

- 3 oz. honeydew gin (Add 0.5 L of honeydew juice to 1 L gin. Pass honeydew through chinois to procure 0.5 L of juice, and combine with gin.)
- 0.5 oz. fresh lime juice
- Top with cucumber and thyme soda (*see recipe below*)
- Mint/thyme/melon for garnish

Directions

1 Shake until shaker is chilled.
2 Strain neat into a small wine glass and top with 1.5 oz. of cold cucumber soda.
3 Garnish with mint/thyme/melon.

Cucumber and Thyme Soda Recipe

- 1 L cucumber juice finely strained through chinois (cheesecloth if necessary)
- 0.5 L honey thyme syrup (slowly steep two parts water to one part honey, or 1 L water to 0.5 L honey with a healthy dose of thyme.)
- Charge plastic soda bottle at 80 PSI.

Recipe courtesy of
Highland Park Bowl
(page 104)

The Roger Room

Two neon tarot cards indicate that you have arrived at the **Roger Room**; step inside and your good fortune grows. The shotgun-style space is small and the decor circus-themed; when it's busy you have to make like a contortionist to get a place at the bar. There are but twelve stools; fate has smiled on you should one be available. If not, let the front door know, and they will offer to call when there's more space at the bar.

The Roger Room was first opened in 2009 by two longtime players in LA nightlife, Sean MacPherson and Jared Meisler, who together and apart are responsible for some of LA's most successful bars of the 1990s and 2000s, including **Bar Marmont** (page 98), El Carmen, Good Luck Bar, Jones, and Bar Lubitsch. Shockingly, all of these bars are still around after two decades, remaining relevant in a field of fast changes. The Roger Room does so by bucking trends and staying true to a pretty simple formula: every drink on the menu has to be amazing. It sounds simple, but upon opening such cocktailery was groundbreaking— the craft was newly emergent, and, while mixology fans were discerning, most folks didn't know swill about it. (Side note: it's possible that the first appearance of black vests and suspenders that became the default uniform behind the bar in speakeasy-style joints started here, at least for Southern California.)

The Roger Room
370 La Cienega Blvd.
West Hollywood
therogerroom.com

The Roger Room was a much-needed antidote to all the seriousness, taking house infusions and homemade mixers

and making beverages delicious *and* fun with witty asides, like a plastic monkey cocktail pick swinging from the **Old Sport** (page 206). The thoughtfulness and skill with which the drinks are made appeals to cocktail aficionados, but the affability of the bartenders makes such art accessible to everyone.

Damien Windsor, of the consulting firm For Medicinal Purposes—a man who has left his mark on the best cocktail programs in town—was a bartender here and helped create many of the drinks. Windsor's take on the Gold Rush is called the Thug and heats up the whiskey-honey-lemon blend with habanero-infused bitters. Another of his creations is a boozed-up refresher called the Tijuana Brass, which consists of Rancho Alegre Blanco tequila, lime juice, agave, and cucumber foam served on the rocks. Also admirable: the bar offers a modern twist on the old-fashioned (rum and coffee syrup, orange zest, and maraschino on the rocks) that pays tribute to writer John Fante, whose 1939 novel *Ask the Dust* is required reading for any Los Angeles lover.

The drinks are always made right, but the most-cared-for cocktail in the room is whatever you just ordered, regardless if it came off the menu. Bartenders are ready to educate, illuminate, or banter depending on your disposition. Even in the dark atmosphere, California's sunny optimism prevails, and positivity pervades the place. That is by design (even the coasters say "Yes"); the bar's name comes from the phrase "Roger that": an affirmation that the message is received.

Old Sport

Ingredients
- 1.5 oz. Botanist gin
- 1 oz. cucumber juice
- 0.75 oz. lime juice
- 0.5 oz. black-tea-infused Soho lychee liqueur
- 1 bar spoon agave nectar
- Cucumber slice for garnish

Directions
1 Combine ingredients in cocktail shaker.
2 Add ice, shake, and strain into large cocktail coupe glass.
3 Garnish with a cucumber slice.

Recipe courtesy of
The Roger Room
(page 204)

Chez Jay

The story of **Chez Jay's** founding
sounds like a cliché from a
screenplay—a struggling actor buys a
failing cafe for $1 over breakfast one
morning when he's hungover from
the night before—which is perfect
since there are few places more
filled with Hollywood lore than Jay's.
Enough hijinks have happened in
this tiny beachside shack to supply a
screenwriter an oeuvre to match that
of Preston Sturges.

That aspiring actor was one Jay
Fiondella, a good-looking, part-time
bartender and full-time romantic,
whose adventurous life lives on in the
artifacts that line the walls of this fifty-
eight-year-old restaurant/bar. From
the get-go, Fiondella had a knack for
knocking off Tinseltown, naming the
restaurant Chez Jay in homage to Chez
Joey, a restaurant in a Frank Sinatra
film. Soon enough, Sinatra and the rest
of the Rat Pack would become some
of his most frequent customers (they
often reserved table #10).

Fiondella's bombastic character and his
sense of showmanship were evident
from day one: he hired showgirls and
a circus elephant for the restaurant's
grand opening. The elephant, which
must have taken up most of the tiny
space, gorged on the baskets of free
peanuts around the bar. Both a dent
that the animal's trunk made in the
bar and the tradition of the peanuts
remain. Don't be neat about it; you are
encouraged to toss the peanut shells on
the sawdust floor.

Chez Jay
1657 Ocean Ave.
Santa Monica
chezjays.com

By the 1960s, Chez Jay was the place for celebrities—an unlikely and unpretentious hot spot where they could be sure to have a good drink, a good meal, and a good time. Fiondella made sure of it by refusing to talk to reporters and kicking anyone with a camera to the curb. Along with the Rat Packers, his loyal following of well-heeled customers included Marlon Brando, Richard Burton, Cary Grant, Peter Sellers, Clint Eastwood, Judy Garland, and Jane Fonda. Lee Marvin once rode in on his motorcycle for shots at the bar.

But it wasn't only the Hollywood elite that loved Chez Jay. Henry Kissinger met Warren Beatty for meals here; and a group of NASA astronauts, training at the nearby RAND Corporation, became frequent guests. Alan Shepard even took one of Chez Jay's peanuts to the moon, smuggled, appropriately enough, in a film canister. Along with the boozy fun and glittery cast of characters, Jay's also had a dark side of political intrigue: it's rumored the Pentagon Papers were given to the press here (at the same table, #10), and two members of the Weather Underground, the domestic terrorist group, were arrested after meeting here.

In all the years, the only thing that's changed at Chez Jay is the addition of a patio outside, called Jay's Patio, which was built to service the new neighbor, Tongva Park, built in 2013. Other than that, the cultural watering hole remains like so many of the relics on its walls: a one-of-a-kind treasure.

Gibson

A take on the martini, the Gibson cocktail replaces a garnish of olives or lemon with a cocktail onion.

Ingredients

- 2 oz. gin
- 1 oz. dry vermouth
- Tools: mixing glass, bar spoon, strainer
- Glass: cocktail
- Garnish: 1 to 2 pickled cocktail onions

Directions

1 Stir ingredients with ice.
2 Strain into a chilled cocktail glass, and garnish.

Recipe courtesy of Heike Macklin,
twenty-year bartender at Chez Jay
(page 208)

Idle Hour

Los Angeles is known for some fine examples of what is called programmatic architecture, a style popular in the 1920s and '30s in which a building physically resembled its purpose. Over the decades, the city has boasted a hot-dog stand in the shape of a hot dog (Tail O' the Pup); a famous Hollywood restaurant shaped like a hat (The Brown Derby); a camera store shaped like a camera (The Darkroom); and many donut shops shaped like donuts (Randy's Donuts, The Donut Hole). The appeal of these structures was that they could easily been seen—and serve as advertisements for their products—from a moving car. As the automobile became more popular as a mode of transport, so did these roadside wonders, luring drivers in to enjoy the goods.

Built in 1941, the Idle Hour Café was a taproom in the shape of a whiskey barrel. The distinctive-shaped building was, fittingly, a tavern until the 1970s, when Dolores Fernandez, a famous Flamenco dancer, and her husband bought the building and renamed it La Caña Restaurant and Flamenco Club. For nearly a decade the couple performed there and had many old Hollywood stars as patrons, including actress and director Ida Lupino. In the late '70s, the business closed, but Fernandez resided in the building, teaching students flamenco in the old barrel. After she retired in 1984, she continued to live in the deteriorating structure until 2005.

Idle Hour
4824 Vineland Ave.
North Hollywood
idlehourbar.com

Almost a decade later, a local preservationist tipped off bar owner Bobby Green—a lover of vintage LA—that the building was coming up for auction. His **1933 Group** (page 70) purchased it and set about restoring the barrel to its original glory. As Green explains, "Our intention with both places (**Idle Hour** and **Highland Park Bowl** [page 104])was to maintain an authenticity to the past, while making the bars accessible to modern times. When we acquired Idle Hour, the structural integrity had been compromised by years of neglect and weather damage. We had to strip the building down and essentially start from scratch, utilizing new materials while at the same time holding to the preservation standards of the city. It was a rigorous task, to say the least."

After three years of work, in 2015 the formerly abandoned landmark was back. And Green didn't stop with just restoring the barrel—he added another icon of programmatic architecture to the patio, a replica of the famous 1925 Bulldog Café, which had formerly been housed in the Petersen Automotive Museum. Today, you and fourteen other friends can have a cocktail inside the gigantic, pipe-smoking bulldog. As is fitting for this slice of Americana, perched perfectly in the cradle of the San Fernando Valley, the cocktail menu offers a democratic selection of handcrafted, draft, and bottled cocktails.

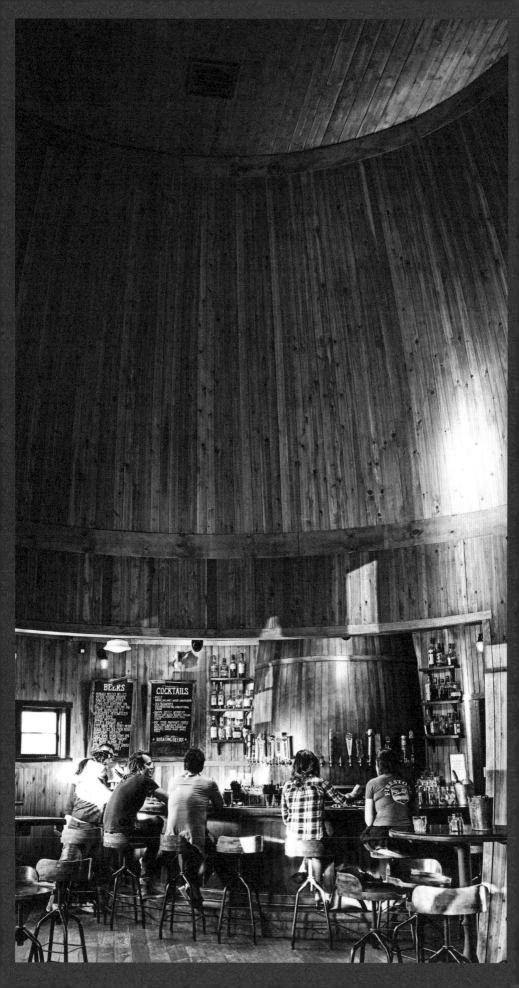

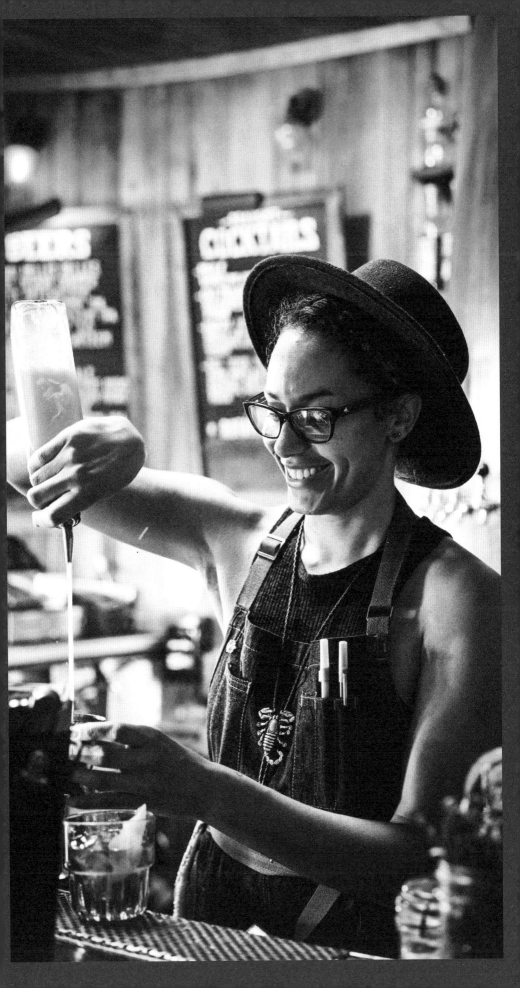

The Bulldog

Ingredients

- 2 oz. Bulldog gin
- 0.5 oz. Chareau aloe liqueur
- 0.75 oz. lime juice
- Basil
- Basil leaf for garnish

Directions

1 Muddle the basil gently with Chareau aloe liqueur.
2 Add the rest of the ingredients and shake.
3 Strain into a rocks glass.
4 Garnish with basil leaf.

Recipe courtesy of
Idle Hour
(page 214)

Aperitivo/
Amaro

"Here's to alcohol, the rose colored glasses of life."

F. Scott Fitzgerald, *The Beautiful and Damned*

The Normandie Club and The Walker Inn

Perhaps the best way to conquer any lingering New York-Los Angeles divide is to focus on collaborations between the two coasts that really work: one is the partnership between **213 Hospitality** (page 158) and Proprietors LLC that resulted in not one but two great Koreatown bars. First, the **Normandie Club** opened in 2015, inside the newly renovated Hotel Normandie. The dark bar has a low-key but stylish feel, with curved leather booths and exposed brick. The focus here is reinterpretations of classic cocktails, and the menu keeps it tidy with a list of seven classic drinks—spritz, sour, collins, Bloody Mary, martini, old-fashioned, and the manhattan—that serve as a category of sorts that can be tweaked and changed over time. So the collins you have here one month might be gin and mandarin orange, and the next: tequila, pineapple, and pear brandy. There are also two cocktails on draft and the same super Seltzer system that is at another Proprietors LLC bar downtown, Honeycut.

There's plenty to enjoy hanging out in the Normandie Club, which feels much like a neighborhood bar for a very busy—and changing—neighborhood. But if you've made reservations, or even if you haven't (they do allow walk-ins), you should also check out the **Walker Inn**, the smaller bar located in the back of the Normandie Club. Once again, the bar owners, who also run **Bar Jackalope** (page 28) and the **Varnish** (page 58), love a sort-of-secret back bar. The twenty-seven-seat room, with just seven seats at the bar

The Normandie Club and
The Walker Inn
3612 W. 6th St.
Koreatown
thenormandieclub.com
thewalkerinnla.com

(the floor behind the bar has been lowered so a bartender can always look a patron in the eye), specializes in creating new cocktails via all sorts of techniques and technology, the majority of which happens behind-the-scenes. This is not a showy, molecular-mixology-type place, although the drinks certainly do come with their own drama and the bartenders know their way around an immersion circulator. The idea is to combine exceptional customer service (there's always the option for bartender's choice here) with cutting-edge cocktail creation. The results are often whimsical, smart, and delicious. And there are two separate menus: one of house classics, the other a tasting menu focused on either seasonally inspired or thematically inspired components (Alice Waters was once a theme, as was the cult movie *Wet Hot American Summer*).

If the Varnish is where you go to get the highest elevated version of a classic cocktail, the Walker Inn is where you come to watch a skilled bartender do creative play. Even a traditionalist will enjoy the results. The intimate setting of the bar leans toward mid-century decor with the Art Nouveau wallpaper that joins the bar, at least aesthetically, to the Normandie Club. And the Walker Inn is taking great hospitality a step further, offering ten themed rooms in the renovated Normandie Hotel—each of which, of course, features its own mini bar.

Apple Mint Spritz

Ingredients
- 1.5 oz. dry vermouth
- 0.5 oz. St. Germain
- 0.25 oz. Clear Creek pear eau-de-vie
- 0.25 oz. Clear Creek apple brandy, aged two years
- 1.25 oz. clarified green apple juice
- 0.5 oz. mint stem syrup
- 0.25 oz. clarified lime juice
- 1 drop salt solution
- Sprig of mint for garnish

Directions
1 Prepare a wine glass with ice cubes.
2 Combine ingredients and pour over ice.
3 Garnish with a sprig of mint.

Recipe courtesy of
the Normandie Club
(page 224)

Harvard & Stone

Houston Hospitality (page 138), led by twin brothers Mark and Jonnie Houston, has—over the course of a decade and eleven bars—proved they excel in creating themed bars with great craft cocktails. They can effectively summon up entire countries (La Descarga, page 138; Pour Vous, page 138) or decades (No Vacancy, page 138; Good Times at Davey Wayne's; Break Room 86) and make a night at a bar feel adventurous, nostalgic, or fun—or all three. Harvard & Stone might seem like a departure from the more exotic themes and speakeasy styling, but it's not: it's just that the theme is an American rock-'n'-roll bar. ("A real Springsteen thing," is how one of the bartenders described it.) And Springsteen you get, plus the usual accoutrements of a Houston bar: irreverent but carefully made cocktails, crowds, and courtesy. There's almost nightly live music—mostly rock or blues—and it's good too. In the back is the famed R&D Bar, where nightly guest bartenders experiment and play.

Harvard & Stone
5221 Hollywood Blvd.
Hollywood
harvardandstone.com

Fernet Cocktail

Ingredients
- 0.75 oz. Fernet-Branca
- 0.75 oz. Carpano Antica
- 0.75 oz. ginger syrup
- 0.75 oz. fresh lime juice
- Club soda
- Lime wheel

Directions
1 Combine ingredients.
2 Pour into cocktail glass over ice.

Recipe courtesy of
Harvard & Stone
(page 228)

Original publisher
SIME S.r.l.

Co-published and distributed
in United States and Canada by
SUNSET & VENICE, LLC

Text
Andrea Richards
Copy Edits
Sara DeGonia
Design
Italo Meneghini
Prepress
Fabio Mascanzoni

Photographers
All images are by Giovanni Simeone,
except:
Brook Mitchell p. 4-5, Iona Wellmann
p. 99, Mauro Coccia p. 152, p. 196,
Stefano Coltelli p. 238-239

Most of the photos are available on
www.simephoto.com

I Edition 2017
ISBN 978-88-99180-56-0

Distributed in Europe by SIME BOOKS
www.simebooks.com
T. +39 0438 402581
customerservice@simebooks.com

Distributed in United States and Canada
by SUNSET & VENICE, LLC
www.sunsetandvenice.com
T. 323 223 2666